WALTER CHANDOHA

HOW TO PHOTOGRAPH CATS, DOGS, AND OTHER ANIMALS

CROWN PUBLISHERS, INC
New York

For Paula

Library of Congress Catalog Card Number: 72-96653
ISBN: 0-517-503492

Printed in the United States of America
Printed simultaneously in Canada by
General Publishing Company Limited
Designed by Shari de Miskey

Second Printing, July, 1973

CONTENTS

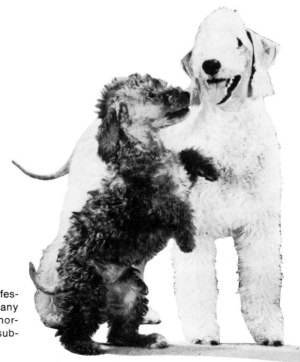

An easy shot for a professional because of many years of training and a thorough knowledge of his subject.

THE BEGINNING

Everything has to begin somewhere. A war, a love affair, a career—each had its small beginnings. Da Vinci's first efforts and his great masterpieces were without doubt poles apart. Hemingway's style evolved after many years of trial and error. And a great racehorse like Citation was once a green yearling.

It's the same with photography. To make outstanding photographs, consistently, day in and day out, takes a lot of learning. The ease with which a successful photographer makes a picture is the result of his drawing from past experience—mostly good but some not-so-good. He knows his equipment; it is tested and tried and in top working order (almost always). He usually knows something about his subject. Technique? He knows it like his own telephone number. He works with assurance because he knows what he is doing. He is confident he can make the required picture. And if he is a specialist, he can probably make the required photograph faster, better, and more economically than any other photographer.

After you have read this book, studied the illustrations, and tried some of the techniques, you still won't be an expert animal photographer. But you will know *how* to *become* that expert, for I'll tell all my secrets, all my techniques, everything that I do to make my pictures sell.

Secret #1: The secret to becoming the best of anything, in any field, is lots of hard, knowledgeable work, a little luck, and the determination to succeed in whatever you've set out to do. Hard work, luck, and determination will make

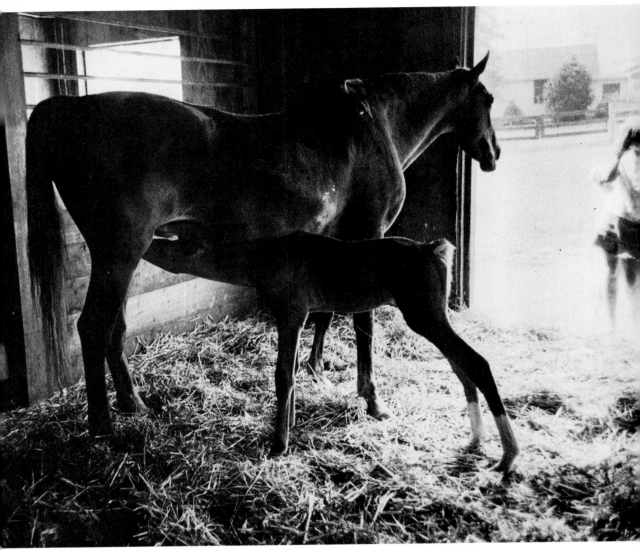

With today's fast films and automated cameras, photographers have fewer technical problems to conquer than in the "olden" days.

you a top-notch animal photographer in a very short time—how short depends on how soon you want to be top-notch. Chances are it will take you a lot less time than it took me. I had no one to tell me what to do or how to do it. And the equipment available to you today is far superior to what I had when I started—not quite in the era of the glass plate, but when you consider that a fast black-and-

white panchromatic film in those days was about ASA 64, you will realize how much we have progressed in 25 years.

The next few pages will be mostly biographical, so those of you who want to get to the meat of this book can skim rapidly through this part. But not too fast because every so often I'll probably digress, and the digression just might contain the answer to a photographic problem that has been bugging you ever since you started in photography.

My start in photography was much like that of many teenagers today—in high school. But judging from the fine equipment I now see youngsters carrying, the similarity ends. My first camera was a 116 folding Kodak camera—the family treasure. Film was bought at the corner drugstore (the druggist always loaded it for us), and after eight memorable events each of which merited a single exposure, the film would be returned to the pharmacy for processing—for 25¢ a roll developed and printed. Surprisingly, the pictures were not too bad. First of all, they were made in bright sunlight with the sun striking the subject full front. And they almost always were of static groups, standing ramrod straight, and rendered immobile by the command to "hold it" by the cameraman, who himself was holding the camera firmly against his belly while looking through the tiny mirror reflex finder. With all these precautions the resulting pictures were not too bad—but not too good either.

So, when the photography bug bit me in high school, this was the camera I started with and the corner drugstore was my "custom" lab. I read everything and anything I could find pertaining to photography. A lot of what I read I didn't understand, but I read it anyway. Most of my first reading came from the local library and second-hand photo magazines: *Popular Photography, Minicam, U.S. Camera, American Photography,* and *Camera.*

The more I read the more I realized that I needed a new camera. My choice was a 35mm Baldina with a fast, fast, fast f/3.5 lens. No coupled range finder, no through-the-lens metering; not much of a camera by today's standards, yet for me it opened up a whole new world and started me on both a hobby and a profession.

But even with the help of the Baldina, I made a rotten start. Everything that could be done wrong, I did wrong. Faulty focus, bad exposures, uncomposed pictures, camera movement, subject movement, scratched negatives, water spots, black and white spots on prints—think of any mistakes you've ever made, and chances are I made those same errors. But I was learning. And I rarely made the same mistake more than once.

Though I was learning, I always had excuses for my rotten pictures. Usually I blamed the lack of proper equipment. My out-of-focus pictures I blamed on the lack of a range finder. This was a device about three inches long and a half-inch square, which was focused by bringing two images together (just as we do today with coupled range finders). A wheel on the range finder would indi-

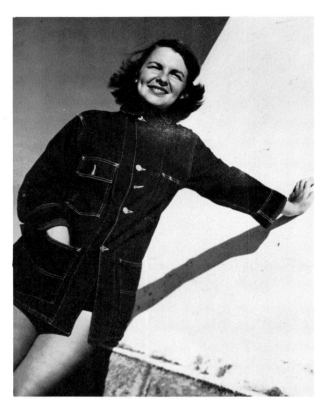

Before I began specializing in animals, my photographic interests were many and varied, with much emphasis on "camera-club pictorials" similar to this group.

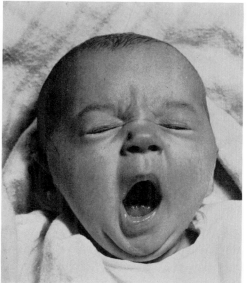

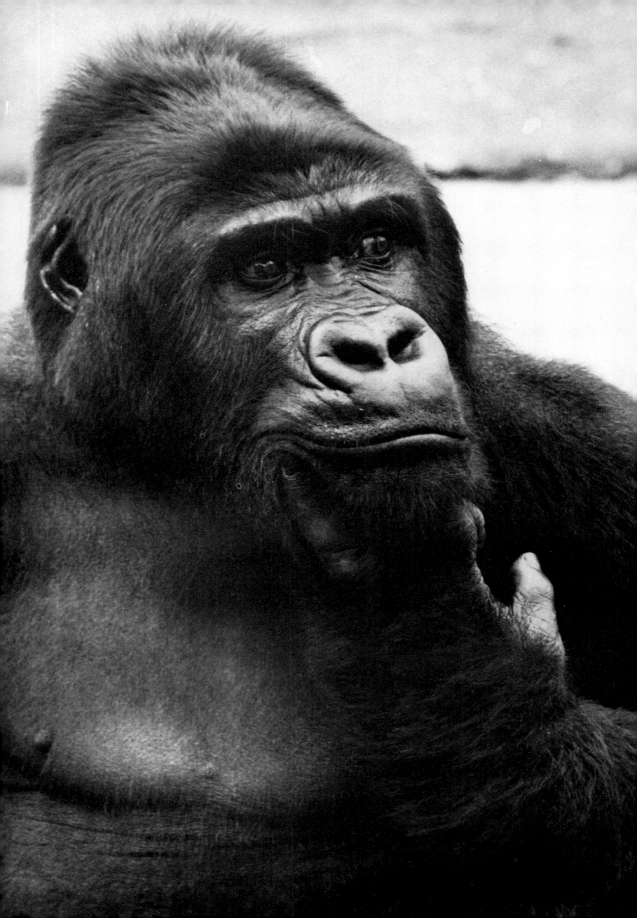

cate the proper distance, which was then set on the Baldina by rotating the front element of the lens to the proper footage. When I finally obtained a range finder, albeit uncoupled, I had to get sharply focused pictures because I no longer had any excuse for poor distance judgment.

Then I had the problem of poorly exposed negatives—not color, mind you, but poorly exposed black and whites. On bright sunny days or in other outdoor situations I didn't do too badly—I followed the instruction sheet packed with the film (more about this later). But even so, shots taken on dull, overcast days were badly exposed and the indoor shots were disasters. I did not have enough experience to estimate indoor exposures accurately. If only I had a light meter, all my photography problems would be a thing of the *past!* Once I got the light meter, my pictures were well exposed but still lousy pictures.

Finally I reached the point after much practice, where I could make sharp, properly exposed pictures. As I perfected my darkroom techniques I could make prints of good quality, but still the pictures were only so-so. In content, they were sort of "so-what?"

It was sometime in these formative photographic years when I suddenly realized that equipment alone does not make a good photographer. The nuts and bolts—the actual technique of taking a picture—this is easily acquired. The eye and the mind to *see* good pictures—they are quite another thing.

◄

Camera equipment alone does not make a good photographer. He has to develop his mind and his eye to see good pictures. The ape's quizzical expression makes this a better than ordinary shot.

2 LEARNING TO VISUALIZE

WITHOUT THE ABILITY to visualize—to see in your mind an approximation of the picture you want—you would be better off not to contemplate getting involved in creative photography. Creativity must first occur in the mind of the artist, and only after it bounces around in the recesses of his brain is he able to put something on canvas, carve it out of stone, or capture it on film.

Can the ability to visualize be acquired? I would say it can. The mind was the forerunner of computers long before IBM or Honeywell ever existed; it is the original computer. A computer stores bits of information on allied or diverse subjects, and when properly programmed, spews forth the parts of the stored information pertinent to the questions asked of it.

The mind of man has been doing this computer thing for over a million years. Bits of information are stored in the mind both consciously and subconsciously. When you require certain information, your memory core gives you the facts you need—how many inches in a foot, how to tie your shoelace, Georges Braque was Cubist (not a square, however), when the needle is on E you'd better put gas in the car, and so on.

Now, if you want your mind to be a more effective computer with a creative memory core, you must feed it with more information. Photographic information, by all means, plus any knowledge that might develop your potential to visualize.

All creative techniques are interrelated—they all have the common denominator of color, composition, and content. Since all art forms contribute to the

Seeing a picture in the mind before seeing it in the viewfinder is a prerequisite to being a successful professional. To get this rat's-eye view of a cat, I cut a hole in a piece of wallboard and nailed it across a doorway. Lights were set up, the cat was brought in, and the shot was made. Without first seeing this picture in my mind, I could not have made it.

development of your memory bank, you should constantly bombard your senses with all kinds of creativity: photography, art, literature, films, music, sculpture, dance—each one with all its many facets.

Since your interest is primarily photography, to become a good photographer you must develop your ability to visualize, to "think" pictures. And that's what this section is all about—probably the most important part of this book. The best starting point for developing the ability to visualize is studying publications that use photographs: *National Geographic, Vogue, Harper's Bazaar, Woman's Day, Playboy, Sports Illustrated, Newsweek,* big city newspapers and their Sunday supplements, the hundreds of technical magazines, travel brochures, corporate annual reports, encyclopedias, books—above all, study ads, for the challenge facing Madison Avenue is never-ending—study anything that uses photography; the list is endless.

You should subscribe to as many magazines as you can afford and as interest you. By actual count, we receive 32 different publications every month in our house. Your local library probably has a selection of at least 100 publications. Make a point of going there at least once a month to look through those you don't get at home.

If you have to skimp and save somewhere, don't do it at the expense of subscriptions to photographic magazines: *Popular Photography, Modern Photography, Camera 35,* certainly—and possibly some of those directed to the profes-

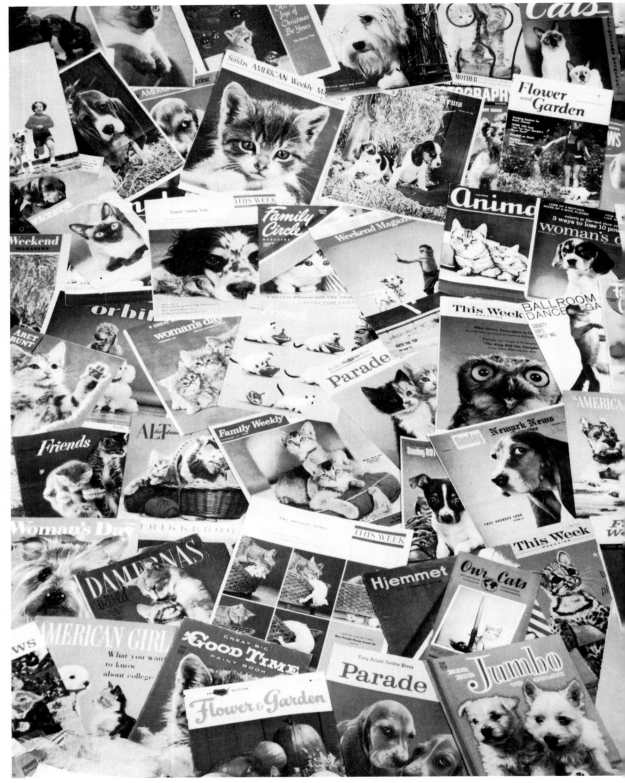

You can learn to visualize by studying pictures in magazines—all magazines—especially those that use many photographs. These are some of the more than 200 covers I've had published.

By studying the photographs being published currently, you'll stay abreast of trends. Multiple flash, existing light, high key, diffusion, wide angle—all are techniques that are now widely used, and at times one or another catches the fancy of editors.

sional like *Photographic Business and Product News, Studio Light, Applied Photography,* and *The Professional Photographer.* And if you really want to extend yourself, subscribe to *Camera Magazine,* the one that is printed in Switzerland. This magazine is excellent!

All right, you say, I subscribe to the photo magazines plus a few others. I go to the library once a month to study many more. But what am I looking for? First of all, study the pictures and become aware of what is new and what is current. What are the trends? If you had studied magazines about twenty years ago, you would have noticed a trend away from the direct multiple-flash type of lighting to a soft non-directional type of lighting. You knew it was not existing light because you know that light does not normally exist in that non-directional way. Suddenly it would come to you—the photographer was using flash, but he was using the ceiling and the walls as one big reflector. Before long, all the photo magazines were running articles on the new type of lighting, "bounce light."

Then, as lenses got faster and films got faster, another "new" type of lighting became fashionable, "available light." A few short years ago the wide-angle lens was discovered, and we saw (and still see) a rash of distorted people, animals, machines—almost everything was wide-angle. Next came the fish-eye lens with the circular pictures, and more recently we're seeing many high-contrast black and whites and psychedelic color shots. Diffused pictures are in favor one year and then they're out. And one day, one cold day, a photographer takes his

warm camera out into the cold air, forgets to wipe off his lens, and wow: the diffused picture is discovered all over again.

Currently, the trend seems to be the shining star glittering around the sparkling highlights in the picture—sparkling reflections of the sea, the sun, jewelry, melting ice, rhinestones on a womans' gown, and so on. Photographers are running down to their favorite camera shop to buy, at great expense, cross screens or star filters at about $15 or $20 each. This "discovery" has been around almost since the early days of photography. Do you know how much a star filter cost a photographer before the affluent era of today? A dime, for a three-inch piece of copper screen.

Look at the quality of the pictures you see on the printed page. They're generally pretty good and have lots of snap and sparkle. Are your pictures comparable? *Used by special permission of Corn Products Refining Company.*

Good composition is basic, and most top-notch photographers automatically compose and crop in the viewfinder. Nonessentials are eliminated to emphasize the subject.

By using a single piece of screen in front of the lens, you get the cross effect —lines crossing at a 90-degree angle. Put a couple of pieces of screen together, and you'd get a star-burst effect. By reading this book, you just saved yourself a $15 bill.

But I'm digressing. You're looking through magazines to get an idea of what is currently being bought and published. Keep in mind, when you see a picture on the printed page, that the editor had many alternates to fill that page. He selected the pictures that were published from many that were submitted by photographers, and before that the photographers selected only their best to present to the editor. Also, the work of one photographer was selected in prefer-

The pictures you see published are the result of much selection. First, the editor selected one photographer out of many. That photographer himself had selected the best prints out of many he took or had in his file. Then the art director selected the pictures to be published from those submitted by the photographer. *As published in* This Week *magazine.*

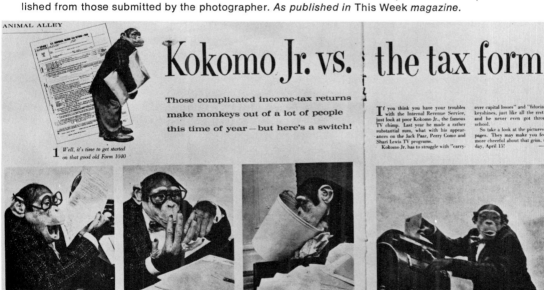
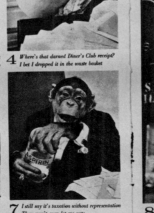

ANIMAL ALLEY

Kokomo Jr. vs. the tax form

Those complicated income-tax returns make monkeys out of a lot of people this time of year — but here's a switch!

If you think you have your troubles with the Internal Revenue Service, just look at poor Kokomo Jr., the famous TV chimp. Last year he made a rather substantial sum, what with his appearances on the Jack Paar, Perry Como and Shari Lewis TV programs. Kokomo Jr. has to struggle with "carry-over capital losses" and "fiduciary" monkeyshines, just like all the rest of us—and he never even got through high school.

So take a look at the pictures on these pages. They may make you feel a little more cheerful about that grin, upcoming day, April 15! —c. d. s.

1 *Well, it's time to get started on that good old Form 1040*

2 *Am I the head of a family? Ha! Didn't they ever hear of the Darwin Theory?*

3 *How many dependents? Can't make it come out to more than one—my owner, Nick Carrado*

4 *Where's that darned Diner's Club receipt? I bet I dropped it in the waste basket*

5 *Well, what kind of lawyer are you? You say I can't even deduct for bananas?*

6 *I swear, this whole business is going to kill me or I'm a monkey's uncle*

7 *I still say it's taxation without representation They won't even let me vote*

8 *Oh well, let's mail it off and hope to Heaven they won't audit me*

ence to that of another. So what you finally see on the printed page is a sort of consensus of opinion on what is best for that particular page. You and I will sometimes disagree with what purports to be the best, but for the sake of this discussion, let's give the editor the benefit of the doubt and say he chose the best.

Next, look at the pictures for their quality. The pictures on the printed page are not always as good as the original photographs, but they will be a fairly good indicator of good print quality. Blacks are black, whites are white, yet there is detail in both the highlight and shadow area, and the gray middle tones are relevant. The pictures have snap and sparkle. Study the quality of the pictures you see on the printed page; then go over the black-and-white prints that you make. Are yours comparable—honestly? Maybe yours are a little gray? Flat and muddy? Highlights washed out? Black, black shadows? Be honest and critical; it's the only way you'll ever learn.

Now look at how the pictures are composed. Are all the components in a picture arranged in such a way that they are pleasing to the eye? Are there any unnecessary elements in the picture? Is it balanced—or is it lopsided? Could the picture have been improved by further cropping? Maybe it was cropped too much. Does something seem to have been left out?

Good composition is basic, and most top-notch photographers are experts at composing a picture properly. They automatically crop and compose in the viewfinder, even before making the exposure. After the pictures are processed, an expert will crop further, if cropping is needed, when he makes his prints. Then the photographs go to an editor or an art director, who will sometimes improve the composition still more—and sometimes mess it up by deleting something in the picture that the photographer considered meaningful—at least he *thought* it was meaningful. All in all, most of the pictures you see in print will be composed and cropped properly, so they will be worth studying.

Let's sum up what you can achieve by studying the pictures that appear in newspapers and magazines: (1) You'll be aware of what is now and contemporary, and what is currently being bought by the press; (2) you'll learn to recognize good print quality; and (3) you'll automatically absorb some rudiments of good composition.

The next step in developing your ability to visualize is to go to photography and art exhibitions. No matter where you live, you are within reasonable traveling distance of some sort of museum, art gallery, library, or exhibit hall where some kind of art is displayed with some degree of regularity. Make a point of attending as many of these shows as you can. As a creative person, you should go to *every one* in your area. And just as you've analyzed the pictures on the printed page, take the time to study the pictures in the galleries. At photo exhibits, you can study original prints; there you'll get an even better idea of what comprises good print quality.

The Metropolitan Museum of Art, the Museum of Modern Art, the Guggenheim, and the Whitney are in New York waiting for you to load your computer memory core with outstanding examples of art that have stood the test of time. Most other big cities also have museums with fine permanent collections. The old masters—Chardin, Rembrandt, Goya, Harnett, Copley, and their kind

By studying original prints at photo exhibits and art galleries, you develop a better understanding of excellent print quality. Compare what you see with the prints you make.

—and the new masters—Picasso, Degas, Pollock, Kandinsky, Miró—and even the still newer masters are all there for your eyes to feast upon.

After you've seen the paintings on the museum walls visit the museum bookstore and buy some of the inexpensive soft-bound books that contain full-color reproductions of the paintings in the various collections. If you can't afford to buy the art books, borrow some from your local library. As you did when you studied photographs in magazines, analyze the paintings for content, color, and composition. To carry your critical analysis of the pictures even further, have a discussion session with some of your photographer friends. A give-and-take discussion sometimes brings out hidden facets of a picture that a single mind might overlook.

The next step in broadening your ability to visualize is to expose your mind to other art forms. Go to the theatre, the movies, concerts, ballet; watch TV selectively, and most important of all, read, read, read! You're already reading the photographic magazines, and you should also be reading as many general magazines as you can afford and have time for. Newspapers, especially your local weekly or daily, should be read cover to cover. Read a book—fiction—at least once a month. Read a nonfiction book once a month. Become a knowledgeable expert on some one subject—any subject—by reading and studying and doing. Pick your own topic—fly tying, growing orchids, the NRA, the American Indian, China (the country), china (the pottery). Whatever subject you choose, you can soon become the most knowledgeable expert on your block *if you take the time to read*.

What, you may ask, has reading got to do with photography—specifically,

While watching a ballet, I noted the similarity between cats and the performers on stage. Soon after, I made a full sequence of a cat ballerina. Exposure to all art forms—theatre, television, movies, concerts, ballet, literature—will give you a more creative mind.

To keep your mind active, read, read, read. This piece of cloisonné acquired as a prop led to the acquisition of other pieces. Now I am an avid cloisonné collector and read anything and everything I can find about it.

"Behind the Eight Ball"—an illustration from a book I'm working on: *Clichés Illustrated.* Only by constant exposure to both the printed and the spoken word can you keep abreast of what's happening around you.

animal photography? Plenty! Reading will make you aware of what's going on about you *now,* of what went on before, and what might happen in the future. You will become an aware person. An aware mind is a mind that can visualize more readily than a sluggish one.

Through reading and constant exposure to all forms of art, you will become more observant of the world about you. You will subconsciously learn to see more. And without the conscious and subconscious effort to see, your creativity will indeed be sparse. Being observant is just another rung up the ladder of success in photography.

3 STUDYING ANIMALS

As you absorb the world about you, filling your mind with creativity, learning to visualize, don't lose sight of your primary objective: you want to become a top-notch animal photographer.

The more you know about a subject—any subject—the better you'll understand it. The more you know about animals, the better you'll understand them and the better you'll be at photographing them.

But to aspire to be a successful animal photographer without also taking the time to study animals is wasted effort. Being observant of animals' habits and customs is the first step to making good animal photographs. Example: A woman's magazine was doing an article on exercising. Somewhere in the article it was mentioned that cats keep in condition by stretching. To illustrate this, the art director wanted a photograph of a cat stretching—front paws extended close to the ground and stretching forward, with the hind end elevated and extending upward.

When the art director asked me if such a shot could be made, I confidently said yes because I was acquainted with the habits of my cats—one of them would do this stretching bit every day. After waking up from a nap, Minguina would get out of her basket, take about two steps, stop, yawn, leisurely stretch forward first with her left front paw, then switch to her right paw, really stretching forward as far as she could. With her front stretching finished, next she'd do her middle stretch. This is the position where the back is humped up like a Halloween cat's.

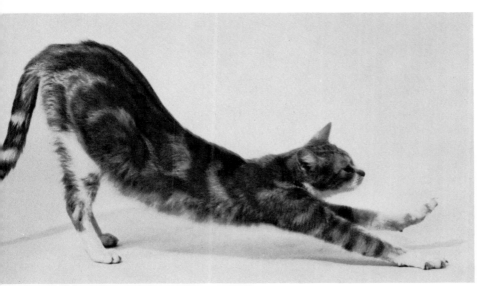

To illustrate an article on exercise for a women's magazine, an art director asked me if I could make a picture of a cat stretching. Knowing the habits of one of my cats, I was confident I could deliver the picture.

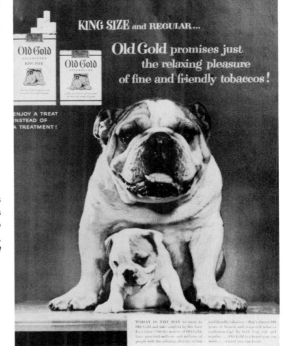

Because a specialist knows more about his own particular field than a jack-of-all-trades does, an art director is more likely to go to a specialist to illustrate an ad like this one, which I did for Old Golds. *Used by special permission of Lorillard Company.*

Having seen my cat do this stretching whenever she awakened, I knew that I could make the required shot. All I had to do was to bring Minguina's basket into the studio, feed her, let her take her usual nap, and be ready and waiting for her when she woke up. When she got up, she hopped out of the basket, took two steps, yawned, stretched forward first with her left paw, then with her right paw, then stretched upward with her middle. As she was stretching, I was shooting pictures.

If I had known nothing about cats, getting this stretching picture could

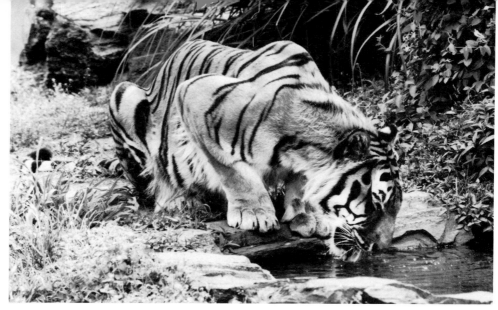

Animals are creatures of habit. They follow the same routine and same pattern day in and day out. Cats—both wild and domestic—like to drink water after they eat. Knowing this habit made it easy to get this shot by waiting until the tiger finished eating.

have been a difficult assignment. Because a specialist in a certain area of photography is presumed to know his subject, he is likely to receive assignments like the one mentioned above; the art director knows he will come back with the required photograph *on time* and with a better one than can be done by the nonspecialist.

So if you aspire to be a specialist in animal photography, observe what animals do and when they do it. The best starting place is in your own home with your own animal, usually a cat or a dog. But even if it's tropical fish, a hamster, or one of the many farm animals, pay attention to its habits. Watch what it does in the morning, in the heat of the day, in the cool of the night. Is it more alert or playful at any one time of the day; how does it behave when it is hungry and also when it is well fed? What is its response to some special sound or food? Does it like to be petted or scratched? How does it react when another of its kind comes on the scene? Does it favor a certain person more than another? What makes it lazy? What makes it active?

After you have stored all *this information* about your animal in the memory bank of your brain computer, see if the same responses hold true for your neighbors' animals of the same species. Compare the reaction of your animals to your friends' animals. Is it the same? If there is a difference, make a mental note of it and try to determine the reason.

Initially, it might help you not to rely on memory alone. Put your observations down on paper. You're going to have to keep a notebook anyway (more about this later), so you may as well include notes about the habits of animals.

Let's say that your pet is a cat and you've been observing his habits for the past few weeks. You've seen that the cat rises early—maybe even jumps on your bed and wakes you up in the morning. You let him out. He's gone for maybe 15 to 20 minutes and he's meowing to come back in. When he comes back in, you give him a bowl of milk, which he laps up slowly and rhythmically; then he

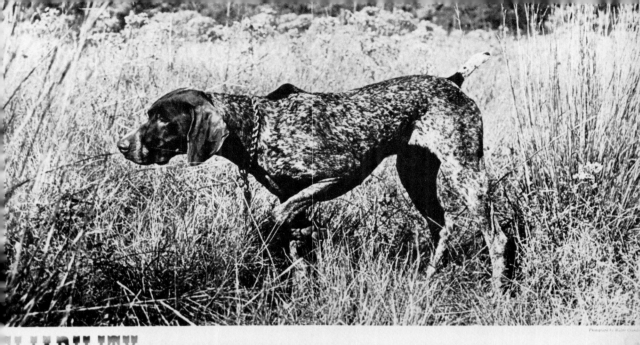

The habits of field dogs are routine. Their first reaction is to run and romp to limber up.
Then they get down to the serious business of hunting. Once they get a scent, a good point
follows—and there's plenty of time to make a shot like this. *Used by special permission of
Keystone Railway Equipment Company.*

moves to a warm, sunny spot and proceeds to wash himself. First he licks his
chops and whiskers clean; then he washes his front paws in turn. Next he'll
wash his back paws and maybe his tail. Having made his paws immaculate, he'll
now use one of his front paws to wash his face and head. About the only area of
his body a cat cannot reach when he washes is the top of his neck between his
shoulder blades—this is why he likes to be scratched in that area.

After the exhausting routine of washing himself, your cat is now ready for
his morning nap. When he wakes up an hour or so later, he'll yawn a couple of
times, stretch, and ask to go out again—this time he may be gone for most of the
day, and if he is a tomcat, maybe he'll be away for most of the night as well. If
he's really sexy, he could be gone for a week or more.

Having observed the actions of your cat for one day, see if he will follow
the same routine the next day, and the day after, and the day after that. Since
cats are creatures of habit, I think you'll find that their routine will not vary
much from day to day. Knowing something about the habits and routine of your
cat, you can see how your task of getting a special picture of him will be easier.
Say you want to get a shot of your cat washing. From your observations, you've
learned that cats wash thoroughly after they have eaten. So to get pictures of a
cat washing, all you have to do is feed your cat until he is full. When he's fin-
ished eating, he'll wash and you'll get your picture.

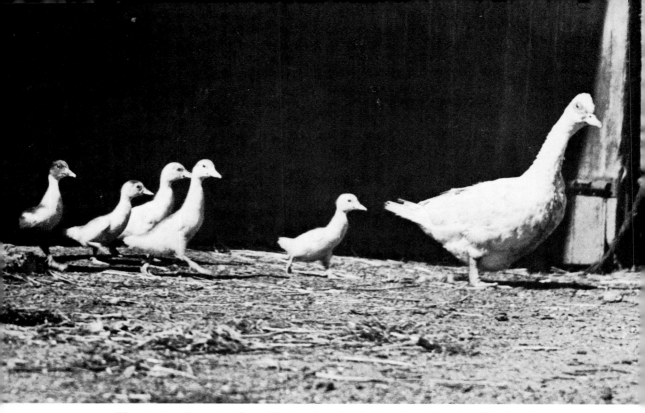

The young of any species will stay close to their mother. Knowing this, I put some corn on the right side of the picture area, let the duck eat, then repeated the process, putting the feed in the same spot. When she saw the feed being thrown, she went for it and her ducklings followed, giving me the chance to shoot this parade picture.

If you want to get a shot of your cat yawning, what do you do? Let him have a nap. When he wakes up, he'll yawn and you'll get your pictures. You want a shot of a cat standing by a door meowing as though wanting to go out? Easy. You *know* when your cat stands by the door wanting to go out, so all you have to do is be there ready for him, and you can get your picture.

Now you can see that it is fairly easy to get a picture of some specific action if you know what behavior to anticipate from a given animal in a given situation. You are getting to be a knowledgeable photographer. As you acquire more knowledge of animals, you'll find you'll be getting better pictures, and you will be getting them easier—and quicker.

When you study photographs and paintings, it should be obvious to you that you should pay special attention to pictures of animals. Begin to compile what art directors call a "swipe" file of animal pictures cut out of newspapers and magazines. Accumulate a library of picture books of animals. The more books you have in your personal library, the greater will be your opportunity to absorb ideas on expressions and poses.

As you evolve as an animal photographer, you'll find you will go back to these books for ideas and, hopefully, *your* pictures will be far superior to those you've used as a guide—or, to put it more bluntly, the pictures you're copying. There is nothing wrong in this type of copying. As a matter of fact, you would do well to select a picture you like (published in a magazine or a book) and deliber-

ately set out to duplicate it. This is one of the best ways to learn. And after you've duplicated the picture, go one step further and improve upon it. Then it becomes *your* accomplishment.

Your primary reason for keeping a "swipe" file and a library of books of animal pictures is to further your knowledge of animals. By studying pictures, you'll learn a lot about expressions and poses that you might not learn from actual observation.

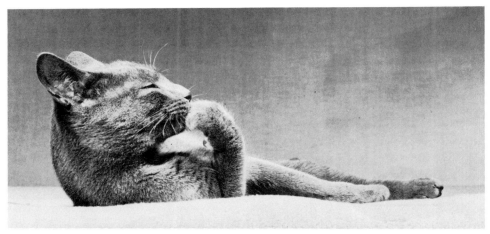

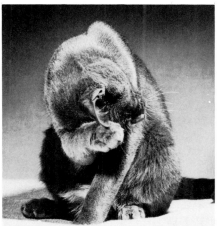

After a cat eats, he washes, and so it's easy to get a sequence of a cat washing. Feed the cat until he is satiated; then, when he starts washing, start shooting pictures.

4 EQUIPMENT

KNOWLEDGE OF animals alone won't make you an expert animal photographer. You're going to have to know something about what kind of equipment to use and how to use it. You've gotten knowledgeable about the habits of animals by studying their habits. You can become knowledgeable about equipment only by working actively with it, by using it. I can save you from making some of the mistakes I made by telling you about the equipment I use, and why I use it.

Let's take cameras first. I have made animal photographs with every kind of a camera from 35mm—both single-lens reflex and range-finder type—through every size and type to an 8×10 view camera and even the special 8×20 view camera that Eastman Kodak Company requires for their gigantic Colorama murals in Grand Central Station.

There are reasons why a given camera was or is used. The big view cameras are used to get large color negatives or transparencies. The Colorama mural in Grand Central Station measures 18 × 60 *feet,* and to maintain good print quality of the photograph, most of the illustrations are made with a special view camera that produces a negative 8×20 inches. On numerous other occasions, Kodak has had prints made for huge outdoor billboards that measured 30×40 feet, and here again, to maintain optimum quality of the finished print, an 8×10 color negative was required. For other accounts, I have used both 8×10 and 5×7 where large transparencies were required.

Fortunately the trend has been away from the large-size transparency. From the 8×10 transparency, I was able to go to the 5×7 transparency, to the 4×5,

I have made animal photographs with cameras ranging from a 35mm to an 8×20 view camera like the one that must be used for the huge Eastman Kodak Colorama in New York's Grand Central Station. *Used by special permission of Eastman Kodak Company.*

By dividing the 60-foot length of this Colorama into panels, I was able to use a 5×7 camera rather than the big 8×20. The five different situations added more variety to the display. *Used by special permission of Eastman Kodak Company.*

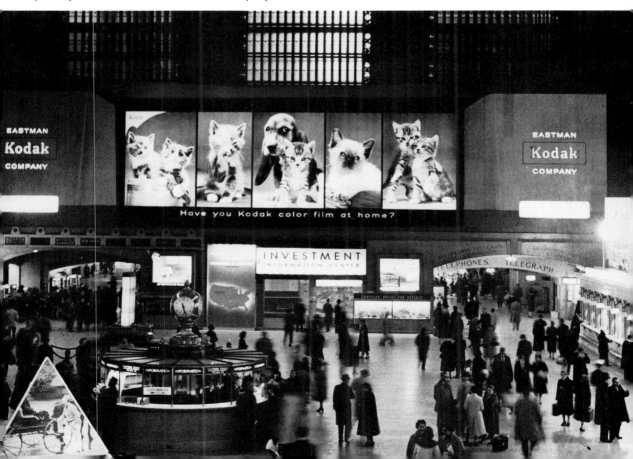

As a professional, my first camera was a 4×5 Speed Graphic. I couldn't afford any other and I didn't know any better—but it made great pictures.

The full 4×5 negative of the preceding picture. The part used is equal to a 35mm negative. Large negatives have their advantages.

to the 2¼ square, to the 35mm. Now, except for special cases where extreme blowups are required, most users will leave the choice of size up to the photographer, letting him use the camera that in his judgment will produce the best job.

The very first camera I used as a professional photographer of animals was a 4×5 Speed Graphic. Why? First, it was the only one I had and I couldn't afford any other. And second, I didn't know any different. At one time in the history of photo journalism, the 4×5 Speed Graphic was the *only* camera to use. It was rugged, simple to use, and it produced a negative that could be cropped and cropped and cropped and you'd still come up with great print quality.

Since I had been doing all types of photography before deciding to specialize in animals, and since the 4×5 Graphic was the camera that could do just about any kind of photography, it never occurred to me that I should not use it for animal photography. I got some excellent pictures with the Graphic, despite its limitations.

But, as I got more and more involved in animal photography, it didn't take me long to realize that the Graphic was limiting my output and the expense of 4×5 film was killing me. So, by going into hock, I bought my first Rolleiflex, and it was like going from darkness into sunlight. The maneuverability with the Rollei compared to the Graphic was fantastic. And the saving in film was substantial. My output soared. That was my first Rollei—the first of four. The fourth one I still use, and I recommend it as *the* camera for the beginning animal photographer.

In the middle of my Rollei period, I got an assignment from *National Geographic* to do a big feature article on cats. When they learned I worked almost exclusively with 2¼ and 4×5 transparencies, they prevailed upon me to try a Leica, and I have been a Leica enthusiast ever since. More recently, I have been using the Nikon for some of my large animal photography, and I am also a Nikon enthusiast.

Now, all the various cameras mentioned above have produced excellent, saleable photographs and were used because of the particular circumstances involved. For the bulk of my shooting, however, I prefer to use *mirror* reflex cameras—the waist-level reflex cameras. I use the Hasselblad for 2¼ color and the 4×5 Graflex when a 4×5 transparency is required. And of course my old favorite the Rollei is still frequently used.

All reflex cameras work this way: light enters the lens, hits a 45° mirror, and is reflected upward to a ground glass viewing screen, where the image can be seen reversed—i.e., a mirror image. What I call a mirror reflex is a twin-lens reflex such as the Rollei and the single-lens Hasselblad and the Graflex. These cameras are usually used at waist level.

What I call the prism reflex takes the image one step further: a five-sided prism receives the image off the mirror and turns it around, *unreversing* the mirror image. Cameras with prisms—the very popular SLRs of today—are usually used at eye level. These would include the Nikon, Pentax (both 35mm and 2¼), Canon, and Leicaflex, plus many others.

It is easier to make pictures of small creatures when you get down to their level. For a picture like this, a waist-level reflex is preferable to an eye-level viewing camera.

◄

The best camera angle for small animal photographs is at the eye level of the animal—which is usually down near the floor or ground. Because viewing is easier at floor level with a waist-level mirror reflex camera, I recommend it for small animal photography.

For close-ups, use longer focal length lenses—the 150mm was used here. They increase the distance between the camera and the subject, thereby lessening the chance of startling your models with the big glass-eyed monster.

Thousands of my animal photographs were made with the Rolleiflex and no doubt thousands more will be made with it. I will continue to use it as long as there is no need for a lens other than the 80mm focal length with which it is equipped. Its rugged construction makes it an ideal all-round camera.

If the Rollei is so good, why switch to a Hasselblad, you might ask. The primary reason is interchangeability of lenses. As stated above, the normal lens on a 2¼ twin-lens reflex is 75–80mm, which is satisfactory for most animal photography. When making extreme close-ups, however, with this "normal" lens the subject-to-lens distance gets to be so short that some animals become too conscious of the big black glass-eyed monster of a camera intruding into their sphere of influence.

By using a 150mm lens on the Hasselblad or even a 250mm telephoto with appropriate close-up equipment, I can move back away from the animals and be less obtrusive and thus be more acceptable to them. Another reason for switching to the Hasselblad and its lens interchangeability is the far-reaching pulling power of telephotos in zoo and field photography. Out in the field, I use mostly the 150mm and the 250mm lenses, and where necessary to reach out farther to get a large-size image, I use the long 500mm telephoto.

So if money is no object and you plan to make a career of animal photography, you can start by purchasing a Hasselblad outfit for several thousand dollars; but if you're in the same financial situation I was in when I first started, I would

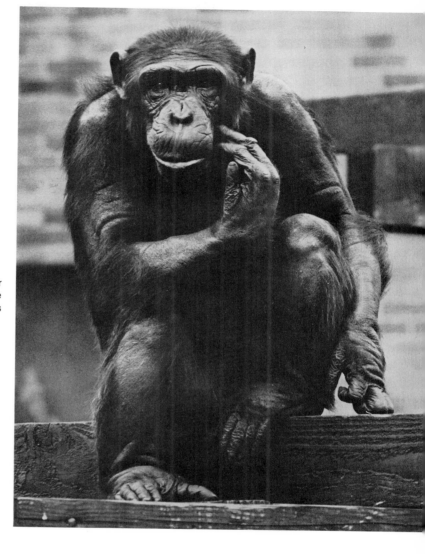

The far-reaching pulling-in power of telephoto lenses is one of the reasons why a camera with lens interchangeability is desirable.

suggest a Rolleiflex as your first camera. Since Rolleis are not as popular today as they were a few years ago, you can pick up an excellent used model for around $75 to $100, maybe less. A Yashicamat, which is an almost identical copy of the Rollei, can be bought new in the same price range.

Later as you become established and more affluent, you can consider getting a Hasselblad or a single-lens reflex 2¼ Rollei, or the Bronica. Small cameras focus from infinity down to two or three feet. Most of the pictures you will make of small animals will require that you move in closer than two or three feet to get a large, sharp image on your film. To do this, you'll need some sort of device to enable you to move in close, and at the same time retain sharpness. The most

commonly used method and the most economical is the close-up lens, also called a portrait lens and a proxar. They come in various strengths, which will enable you to move in as close as eight or ten inches from the subject and still get a sharp image.

For a single-lens reflex, a close-up lens is placed over the camera lens and, depending on the strength of the proxar you've selected, you can now move in closer than the minimum near distance marked on your camera. With twin-lens reflexes such as the Rollei, you'll have to have a matched pair of close-up lenses, one to go over the taking lens and one for the viewing lens. In addition, the viewing lens attachment is fitted with a prism that automatically compensates for parallax.

Parallax is especially a problem with twin-lens reflex cameras. You'll note that the center of the taking lens is about two inches below the center of the viewing lens. For distant pictures the difference can be ignored, but as you get

To get a large yet sharp image on your film, a supplementary close-up or a portrait lens is placed over the camera lens.

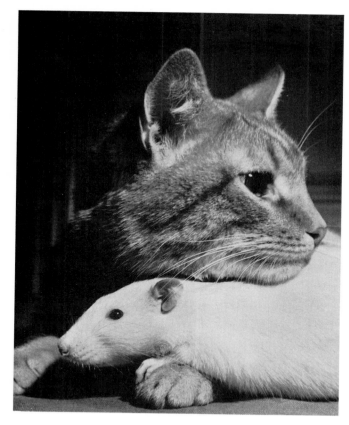

Close-up lenses come in various strengths or powers. The stronger the close-up lens, the closer you can get to your subject—and the bigger the image.

in close to your subject—say, the head of a kitten—you can readily see what would happen. If you saw a perfectly framed picture in the viewfinder, your taking lens would be two inches off center and the picture you'd get would show the top of the kitten's head chopped off. The prism device used in conjunction with the close-up lens on the viewing lens prevents this.

With a single-lens reflex camera, there is no parallax problem because the taking lens is also the viewing lens. This is one of the reasons the single reflex prism cameras such as the Nikon and Pentax are so popular today. But probably the main reason for the tremendous popularity of the SLR is the built-in metering, which enables even the greenest neophyte to get accurate exposures. Now, if you're thinking, you might ask: If the SLR prism type is such a popular camera, why does Chandoha recommend a twin-lens reflex or a single-lens mirror reflex? A very elementary explanation—animal photographs are best when shot at the eye level of the animal. Since the eye level of most of the animals you'll be working with is way down near the ground, you'll be shooting from ground level. If you use a prism reflex or a range-finder camera for ground-level shooting, you'll find yourself crawling around on your belly like a snake—not the most comfortable position for shooting pictures.

With the mirror reflex cameras, however, even if you shoot at floor level, all you have to do to look into the viewfinder is to bend over and look down into it. By resting the camera on the floor or on your knee while shooting, you get the benefit of added stability.

For large animal photography, the eye-level SLR camera or the range finder camera is excellent. And for fast action it might even be preferable to a waist-level reflex.

As added accessories, some SLR cameras with removable prisms have conventional or magnifying viewfinders—i.e., they can be converted into straight mirror reflex cameras. These are fine if you want to shoot all horizontal pictures. It is not easy to shoot verticals with these accessories. On the other hand, both the Rollei and the Hasselblad can be equipped with prism finders, which give these cameras somewhat more usefulness.

Because of the convenience of viewing at low levels, I prefer the waist-level mirror reflex camera for photographing small animals.

For larger animals—horses, for example—or for zoo photography, the eye-level prism SLR camera is excellent, and in many situations preferable to the waist-level mirror reflex. I use both the Nikon and the Leica range-finder camera for large animal photography. But since cats and dogs are the most popular and most numerous pets, I'm assuming most readers of this volume are primarily interested in photographing these animals; hence my recommendation to use the mirror reflex cameras.

Getting back to close-up photography. Despite my recommendation that you use a mirror reflex for small animals, if you have a 35mm SLR prism reflex, by

all means use it. With a camera of this type, you can get a lens designed especially for close-up work. These micro or macro lenses (the terminology varies depending on the manufacturer) will enable you to focus down to life size or half life size without any accessories. These lenses are corrected for close-up work, yet they're superb for all general photography. I use the 55mm f/3.5 micro on my Nikon for 90 percent of my Nikon photography.

Still another method of getting close-ups is with extension rings or tubes. These are metal tubes that are placed between the camera body and the lens. The farther away from the camera body the lens goes, the bigger the image. Obviously, you have to have a camera with interchangeable lenses to be able to use extension tubes. These are sometimes sold in sets of three or four, each ring of a different width to give you different degrees of magnification. They can also be purchased singly. Because light must travel a greater distance from the lens to the film when extension tubes are used, exposure must be increased. The amount of increase is dependent upon the width of the tube.

If a SLR prism reflex is the only camera you own, by all means use it for photographing animals. Macro lenses made for these cameras will let you get close-ups without the need for any attachments.

Still another way to get close-ups is with extension tubes. These are placed between the camera body and the lens. Only for cameras with interchangeable lenses.

A tripod should be used in your first efforts at animal photography. When it is combined with the use of a posing table or stool and careful focusing on your part, you'll be better able to concentrate on the poses and expressions of your models. *Used by special permission of Polaroid.*

If you should ever need to make ultra close-ups, you can combine extension tubes *and* supplementary close-up lenses. Incidentally, when you use the proxar or portrait lens, no increase in exposure is necessary.

A tripod is another piece of equipment that you ought to use in some of your initial animal pictures. The function of a tripod is to give a rock-steady support to a camera. A wobbly compact "pocket" tripod is almost worthless as a support when the legs are fully extended. A good way to test the stability of a tripod is to extend the legs to the maximum, place both your hands on the top, press down, and sort of try to rotate the tripod. If you get a pronounced wobble or side-to-side sway, the tripod is not too stable. Good tripods tend to be big and bulky and somewhat on the heavy side. They definitely will not fit into your gadget bag.

The tripod will be used primarily in conjunction with a posing table, your next piece of required equipment for animal photography. The posing table need not be anything elaborate—an old kitchen table, a bureau, a couple of boards set on some sawhorses; I've even used a high stool. The purpose of a posing table is to limit the movement of the animals. You'll find a bunch of kittens or puppies are a pretty active group and if you don't limit their movement, you'll be spending more time retrieving them than you will in making pictures of them. When most young animals are placed on a posing table, they will roam the 2 × 4 foot surface and that will be it. They may want to jump off, but you or your assistant (more about him later) can easily confine them to the tabletop.

Since you'll have to lend a hand in confining your models to the tabletop, you can readily see that having your camera on a tripod will be a big help. By

using a long shutter release, you can be right up close where the action is and when you see something photo-worthy happening, you'll be able to shoot fast.

Later as you become more experienced and your assistant learns more about handling animals, you'll eliminate the tripod on much of your shooting. But, initially, try pictures of small frisky animals on a tabletop with the camera on a tripod.

THE ASSISTANT

An assistant sounds like a big deal, but you'll really need one in order to make good animal pictures. Your assistant can be anyone who likes animals as much as you do—your spouse, a friend, one of your children, or the owner of the model you happen to be photographing.

The primary task of the assistant will be to keep the animals in camera range whether they're up on a posing table or down at ground level. With your assistant containing the animals, you'll be free to concentrate on pose and expression—most of the time. Until the animals are "settled," however, you'll probably have to pitch in and do your bit to help keep them in place. Hence, you'll need both the tripod and a long shutter release. Notice I did not say long "cable" release, which is one form of shutter release. Another is an air release; this device fits into the cable release socket and connects to a long length of tubing, either rubber or plastic, at the end of which is a rubber bulb. You squeeze the bulb and the shutter goes off.

An assistant can be anyone who can help you get a picture —your spouse, offspring, friend, neighbor, or the animal's owner. In this case the elephant trainer was my assistant.

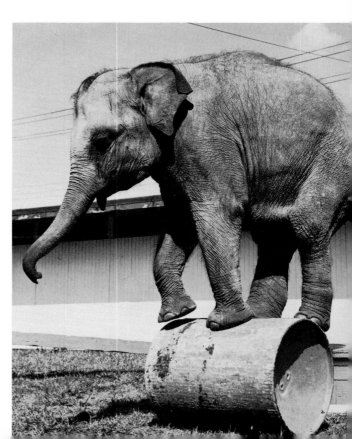

LIGHT

5

You'll be making animal pictures both indoors and outdoors. Let's talk about outdoor shots first. I prefer to shoot outdoor pictures in the shade or on a hazy overcast day. Under these conditions, the light has a pleasing softness and there is less chance for exposure error. Whenever I can, I try to avoid shooting at midday in bright sun. Naturally if I'm at a rodeo or in a situation where I must make a picture, I shoot regardless of the light. But if I have the time or control of the circumstances, I'll wait for the light that I prefer. The high overhead sun of midday does nothing exciting for a picture. If I must shoot in bright sun, I like to shoot early or late in the day when the sun is low in the sky. The low sun "shadows" the subject more interestingly.

Another technique I like is to use the sun for backlighting. This gives a nice even tone in the shadow area, plus a sparkling brilliance where the sun rim-lights the subject. If you use this backlighting technique, make sure you give the shadow area sufficient exposure to get good detail. A quick-guess exposure for backlighted subjects: open up the aperture two stops more than required for the basic bright sun exposure for Kodachrome film, which is f/8 at 1/125 sec.; if you open up the aperture two stops, you get f/4 at 1/125 sec.

Indoor pictures can be made during the day in the average bright room or near a window or a doorway. Today's films, both black and white and color, are fast enough to make pictures indoors during the day without the need of any auxiliary light. But if you want to get away from reliance on the sun, you'll need some sort of artificial light.

39

When shooting outdoors, I prefer making pictures in the shade on a hazy, overcast day, with indistinct, almost invisible shadows. The light has a pleasing softness and there is less chance for exposure error.

When shooting pictures in bright sunlight, try to avoid shooting at midday. Early-morning or late-afternoon sun that is low in the sky gives your subject better modeling.

Use the sun for backlighting. The shadow area gets an even light and the subject gets a sparkling rim light.

This "provided" light, as I prefer to call artificial light, is of two types—flood and flash. Because of the great amount of heat generated by floods, they are not a very good light to use for animal pictures. The animals react in two ways: they get hot and start to pant, or they're so comfortable under the lights that they soon get drowsy and fall asleep. So unless you want a lot of sleepy pet pictures, avoid floodlights.

This leaves flash as the only practical indoor light source. Flash is divided into two groups: the expendable variety like flash cubes and flashbulbs, and the repeating type variously called strobe, speedlight, or electronic flash. If you plan to shoot animal pictures indoors just once in a while, flashbulbs or cubes will suffice. But if you intend to get into animal photography seriously and earnestly, you should invest in a good speedlight outfit.

Some background information on speedlights: They come in all sizes and all prices. Generally, the bigger the unit the greater the light output, and the greater the light output the higher the price. The most inexpensive electronic lights are about as large as a pack of king-size cigarettes and sell for about $15 to $30. These will provide about 50 flashes on a set of batteries or on a fresh charge. A number of these work on both batteries and electric house current (AC). Some of these small speedlight units operate on disposable batteries and some on rechargeable batteries. They all have one big drawback—the recycling time is too long for animal photography, about 8 to 20 seconds. Doesn't seem like a very long time, but if you're shooting a couple of frisky kittens and something interesting happens just after you fire a flash, the great pose or expression will be gone in the ten seconds required for recycling.

A brief word of explanation on recycling time and how electronic flash units work. They all contain an electronic circuit, which is powered by either battery and/or alternating current. A charge is stored in a condenser, and when released, it ignites a gas in the flash tube, and this makes the flash. However, before the condenser can store enough of a charge for the next flash, it has to "fill up." This "filling-up" time is the recycling time. It can be likened to water coming out of a faucet and filling up a bucket. When the bucket is full, you can dump the entire volume quickly and suddenly. But if you had dumped the bucket when it was only half full, you'd have gotten only half the volume. The same thing is true of the strobe flash. If you shoot a picture before the recycling is complete, you'll get a flash but it will not be as intense as if you had waited the full recycling time.

The smaller inexpensive strobe units take longer to recycle primarily because of their size. In making them so small and so compact, something had to be sacrificed. The smaller components make recycling take longer, and of course they give less light output than larger units.

The more expensive portable strobe units made for professional photographers recycle in a couple of seconds and generally are powered by a 510-volt battery and/or alternating current. They cost between $75 and $150. Larger studio strobe units are powered mostly by AC and go from about $300 and upward into

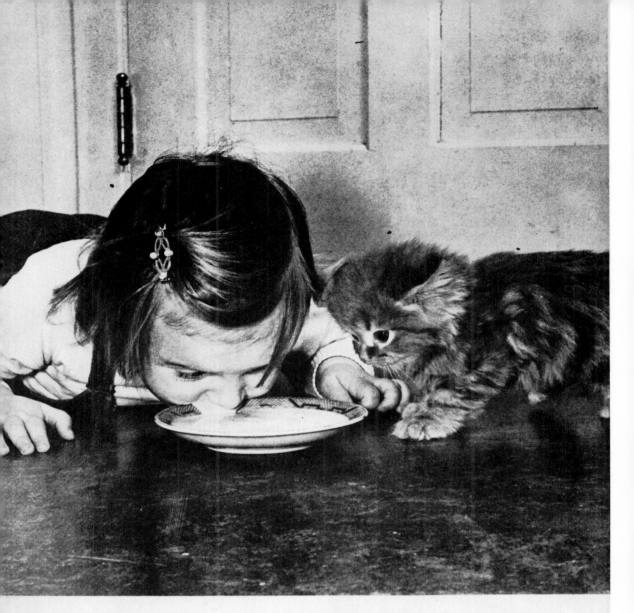

HOSTESS HORNING IN

Minding her manners, Chiara Chandoha did not make any slurping noises and did not spill a single drop. Still, it was questionable etiquette to horn in on the guest's meal. The saucer of milk had just been served to a kitten visiting Photographer Walter Chandoha's household when his 18-month-old daughter flopped to the kitchen floor. Using a technique she had picked up playing with the resident household cats, she started lapping away so fast that the kitten backed away timidly. He resumed drinking his own milk only when invited to join in by his uninvited dinner companion. The family also has a pet dog and his influence has created a problem of linguistic maladjustment for the young lady. Chiara calls all animals—including cats—dogs.

When ''provided'' light is required, flash is preferable to floods. Flash cubes or flashbulbs are fine when shooting infrequently, but if you plan to do a lot of shooting, electronic flash is more economical. *Used by special permission of* Life *magazine.*

Strobe light will stop fast action, but it's just as essential for stopping little nuances of action, such as the kitten's paw momentarily resting on its mother's. That touch, along with the position of the heads of all three cats, makes the composition of this photograph flawless. *Used by special permission of The Quaker Oats Company.*

The more you pay for a strobe unit, the more intense the light and the faster it will recycle. Most strobes will stop even the fastest action.

the thousands. The higher the price, the greater the light output. For animal photography, as a starting point you might consider the type of speedlight used by press and wedding photographers, which sells for about $100. The 510-volt battery powering these units sells for about $15 and is good for about 1,000 flashes. You can readily see that you're going to have to shoot many pictures to justify not only the initial cost of the strobe unit, but the $15 for the battery, which will deteriorate with age in eight months or so. Stay with flashbulbs or an inexpensive strobe unit initially; then if you do a lot of shooting, get the higher-priced unit.

To sum up on equipment: A reflex camera, preferably a 2¼ twin-lens or single-lens mirror-type; close-up lenses or extension tubes; flash—either cubes or strobe; a tripod and posing table; and, very important, an assistant who is readily available to you. Now you are ready to shoot animal pictures.

FILM AND PAPER

THE FILM I USE for animal photography is standardized. For most of my out-
door and available light shooting in black and white, I use Kodak Tri-X film rated
at ASA 400, which is the recommended speed. The engineers and experts at East-
man Kodak Company have—presumably—tested and tried the film at speeds other
than ASA 400, but they suggest ASA 400, so I rate it at 400. There are enough
problems in photography—why create more by altering the recommended speed
of the film?

One of the developers Kodak suggests for Tri-X film is Kodak developer
D-76. What they suggest, I use, and for the times and at the temperature sug-
gested. No problems. No grain. Many years ago I tried juggling formulas and
exotic developers, and the results were unspectacular; some of them, in fact, were
not very good. Somewhere along the line I got smart and realized that Kodak
had a staff of experts up in Rochester doing scientific research on developers. If
they knew of a better way to develop Tri-X film, they would certainly let the
world know about it. Now I follow their advice, and I am happier with the re-
sults.

In the studio, I use Kodak Panatomic-X film. I would prefer to use Tri-X
film in the studio too, but my speedlights are too powerful. Even when I use slow
Panatomic-X film, my cameras are stopped down to f/22 or f/32. This film is also
developed in D-76 developer for the recommended time and temperature.

For 35mm color, my favorite is Kodachrome film (ASA 25), which I use for
all my studio work and 95 percent of my outdoor photography. Where I have to
do pictures in low-light situations, such as newborn foals in dimly lit stables,

Pick a film and stay with it until you've learned all there is to know about it. For best results, expose film at the recommended speed and develop for the recommended time.

circus shots in spotlighted arenas, or high-speed action, I'll switch to Kodak High-Speed Ektachrome film rated at either the normal rating or push processed to double the normal rating.

Kodak Ektachrome-X film is used when I shoot 2¼ or 4×5 both outdoors and in the studio. When I require color negatives, I use Kodak Ektacolor film. Because I get consistently good results with Kodak films and because I am familiar with what they will and will not do under a given set of circumstances, I stay with them. Like most professionals, I don't have the time to switch from one brand to another and to experiment. If, at any time, however, another brand would give me results superior to those I've been getting with an old favorite, I would not hesitate to switch, provided the new film was readily available and could be processed without a lot of red tape.

With even the slower speed color films, there is usually enough natural light to shoot pictures in shade or sun. Care in focusing will get you sharp pictures even at wide-open apertures.

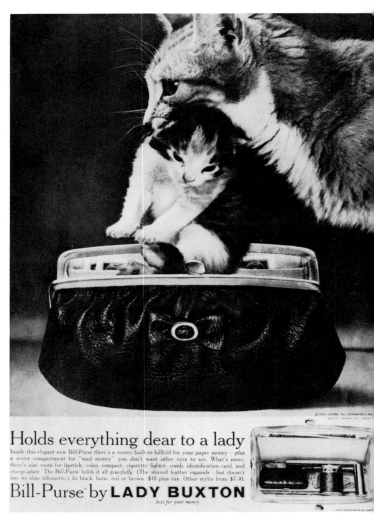

The color film I use in my studio is Ektachrome-X. Like most professionals, I don't have time to experiment with different brands. *Used by special permission of Buxton, Inc.*

I have all my color film processed by professional processing labs or by the manufacturer of the film. The volume of shooting that I do does not warrant on-premises developing.

By standardizing on these films, I have come to know them. If you have been shooting pictures for a number of years, you probably have your own favorites. Whether you use the films I use or some others is unimportant— the important thing is to stay with a film once you find one that you like. Standardize! Don't constantly switch from one type to another just for the sake of switching or because a certain brand gets a glowing report in the photographic press. Standardization of your film and developer will give you a norm from which you'll be able to deviate if it is ever necessary.

I'm going to digress here for a bit to talk about the instruction sheets packed with films, the directions on developer cans, and the booklet of instructions that came with your camera, lens, flash gun, and other photo equipment. These instructions are among the most important pieces of photographic literature you can read. They should be reread regularly. Can you honestly say that you've read the instruction booklet that came with your camera, cover to cover? Even

the basic photography instruction that is in every one? Reread the booklet just to acquaint yourself with little-used parts of the camera and with techniques that are rarely used. Do you know how to lock up the mirror on your single-lens reflex—do you know how to make a double exposure intentionally—which setting to use for strobe or for flashbulbs? And when was the last time you used the hyperfocal distance for fast shooting?

The instruction sheets which are packed with film provide the best lesson in basic photography to be found anywhere. I was going to say it's the best lesson in basic photography that money can buy, but since the sheet comes with the film, that's not putting much worth on something that's good. If photographers were to commit to memory all the information on the instruction sheets, their percentages of well-exposed photographs would increase tremendously.

Even with the superb through-the-lens metering that today's cameras have, it is good to have a system of checks and balances just in case something should go wrong with your built-in meter. It can happen. If you commit to memory a few basic exposures, you'll save yourself much grief if you should have a meter malfunction.

On a recent trip to Montana to photograph horses, I suddenly found the meter of my Photomic Nikon camera was giving me a reading of f/2.8 at 1/250 in bright sunlight. Now I know from memory that the basic exposure for ASA 25 Kodachrome film is f/5.6 at 1/250. So obviously something was wrong. A reading with my Weston meter confirmed the f/5.6–1/250 bright sunlight reading,

Read the instruction sheets that come packed with film. Use the exposure chart as a back-up to check the accuracy of your meter. When my camera meter failed in Montana, I used the charts to check my hand meter.

which is also the exposure setting indicated in the instruction sheet packed with each roll of Kodachrome film.

So I had to ignore the Nikon meter for the balance of the assignment and rely on my judgment, my memory, and the Weston meter, which is part of my back-up system. You should also have a back-up system—a system of checks and balances. Especially if you're shooting something important or when you're in some foreign land on a once-in-a-lifetime voyage. Every so often check the reading the exposure meter is giving you against the instruction sheet packed with the film you're using. If they coincide or are very close, continue shooting. If there is a wide difference, rely on the exposure indicated on the printed instruction sheet. You'll be glad you did.

With film developing, your primary objective is to get the best possible negative, a "normal" negative. I believe this can best be achieved by following the instructions given by the manufacturer of the film. His scientists have tried many, many variations, and those recommended are destined to give the very best results.

Once this "best" negative is obtained, however, the technical aspects of photography take second place to creativity and artistry. The reputation of many a top photographer is the result of very talented and knowledgeable darkroom artistry in making the final print.

Darkroom print manipulation can take many forms: using developer full strength, using it diluted, or a combination of both; using full-strength developer on only certain portions of the print; using hot developer, using chemical reducers, burning in, dodging, using different filters on portions of the same print —the list is endless. A good book on printing will give you the details and the

Creativity in the darkroom can complement your creativity with the camera. Chemical reducers, burning in, and dodging are some darkroom techniques you'll use to get better pictures. The background here was burned in to emphasize the backlighting on the cat.

►

Low-contrast scenes can be sparked up considerably by printing them on a high-contrast graded paper like #5 or #6. This tiger was photographed on a dark day, and so the resulting negative was very flat. But #6 paper made a good print.

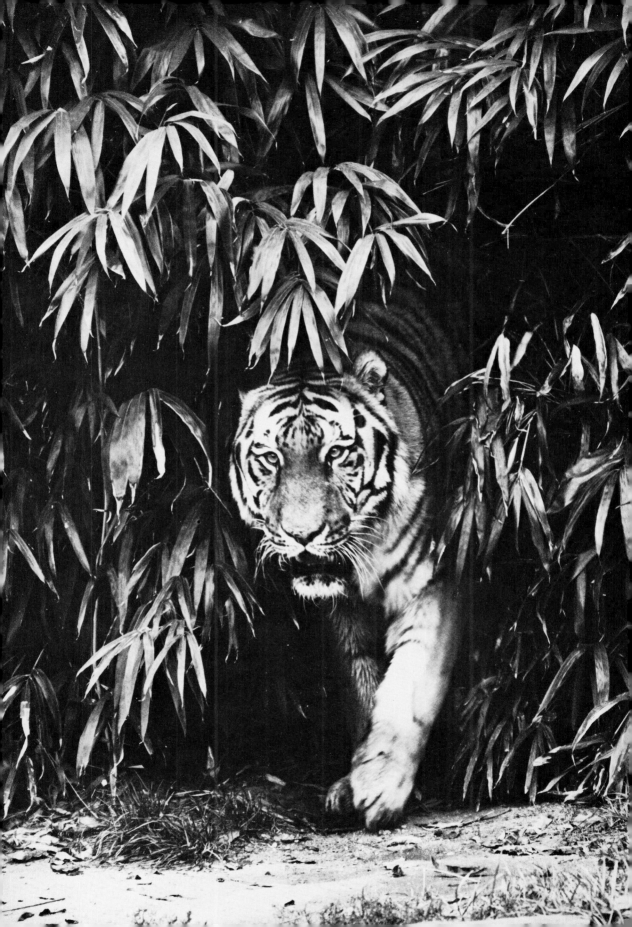

techniques. Here is a list of some of the best books to guide you in this area: *Life Library of Photography: The Print,* Time-Life Books; *Lootens on Photographic Enlarging and Print Quality,* J. G. Lootens, Amphoto; *The Practical Way to Perfect Enlargements,* Joseph Foldes, A. S. Barnes & Co., Cranbury, N.J.; *Darkroom Magic,* Otto Litzel, Amphoto; *Bigger and Better—The Book of Enlarging,* Don Nibbelink, John P. Smith, Inc. The following titles are available from Kodak through Department 454, Eastman Kodak, 343 State Street, Rochester, N.Y. 14650: *Basic Developing, Printing, Enlarging* (AJ-2); *Enlarging in Black and White and Color* (AG-16); and *Professional Printing in Black and White* (G-5).

The selection of a printing paper is subject to so many factors—and prejudices and preferences—that it would be presumptuous of me to make a recommendation. But I can tell you my preferences and some of my thoughts on printing in general.

Enlarging papers fall into two broad categories—graded papers of varying contrasts, and ungraded papers whose contrast is varied by the use of filters. It is more economical to use the ungraded paper. Once you've purchased a set of filters, you'll need to buy but one kind of paper for the bulk of your printing. With graded paper, you'd have to buy at least four different grades to get a good range of contrasts to get started.

My preference? I use a combination of both systems. For the majority of my negatives I use Kodak Polycontrast paper. When the most contrast obtainable with the #4 filter and Polycontrast paper is sometimes not "contrasty" enough, I then switch to a graded paper—Agfa Brovira #5 or #6. These contrasty graded papers would be used if I wanted to print an especially flat negative (professionals make errors too), or if I was looking for a special effect.

Both the Kodak and the Agfa papers are developed in Kodak Dektol developer—pretty much as recommended by the manufacturer. However, darkroom manipulation of the print is one area where you can experiment to your heart's content because you've always got the negative to go back to for a fresh start if your experimentation doesn't work out.

PATICNCE

PATIENCE IS A VIRTUE, but if you aspire to be an animal photographer it is an absolute necessity. Because you're dealing with unpredictable subjects, you'll have to have an unlimited store of patience. Animals cannot be coerced to do something; they cannot be pleaded with, and promises of fame and riches fall on deaf ears.

There are only two ways to consistently get good animal pictures: You have to be patient, and you have to know your subject. But patience must have direction. You can have the patience of a saint—of all the saints—but it will do you no good if you're trying to get a shot of a cat balancing a mouse on the tip of his nose while sitting on his hind legs. If an animal won't or can't do something, no amount of patience will help you get a picture. However, if you know an animal will strike a certain pose or do a certain thing, you can get a picture—eventually.

Forbes magazine recently did a story on the resurgence of the British economy, and for the cover the editors wanted a shot of an English bulldog wearing a bowler with a small Union Jack sticking out of the hatband. They asked me if such a shot could be made, and upon my assuring them it could, I was given the assignment.

To get a shot of a dog wearing a hat is no great problem. They'd rather not wear hats, but if you persist, they'll go along with the gag. So, from past experience (knowledge of my subject), I knew it was a shot that we could do—not too easily, but I knew the shot could be delivered in time.

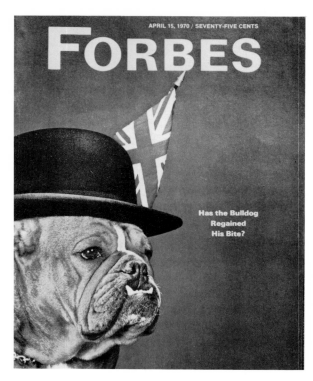

APRIL 15, 1970 / SEVENTY-FIVE CENTS

FORBES

Has the Bulldog
Regained
His Bite?

A dog prefers not to wear a hat, but he will do it if you have the patience to keep trying. Knowing what an animal will or won't do is important. All the patience in the world, however, will not get you a picture if the animal is physically incapable of doing what you want him to. *Used by special permission of* Forbes.

Edith Tramutola, a friend of ours who is a talented writer and photographer, supplied us with our model, a friendly but fierce-looking bulldog named Ginger. We tried the derby on Ginger a couple of times, only to have her shake it off her head disdainfully. We tried again and again—she shook it off. We tried, she shook. Then, somewhere along the line, she noticed the flag, and every time she shook the hat off she'd take a nip at the flag if it got in range. As the shooting session dragged on, the hat began to stay on her head a few seconds longer each time. After a couple of hours and maybe a half-dozen exposures, Ginger got the idea and finally held the hat on her head for a long time—at least thirty seconds, which was adequate to make all the exposures necessary.

To get such a shot was simply a matter of knowing what the animal would do, setting up the situation, and hanging in there until we got cooperation.

Another assignment that almost exhausted my patience was from a dog biscuit company, which wanted a series of ads showing dogs chewing something—anything. The copy theme of the ads suggested that since dogs are going to chew on something, let them chew on something good—Milkbone.

This was going to be one of those easy assignments, I thought. We had just gone through a period of chewed shoes, socks, and chair legs with our young Bouvier, Kittydog, and I foresaw no difficulty in getting other dogs to chew on various objects. But alas, I had not done my homework. By observing only Kittydog, I had limited my knowledge of the chewing habits of dogs to just one dog, a teenager with "itchy" teeth! I didn't know at the time that all dogs do not chew—but how quickly I found out! We tried one dog, then another, and still another. No matter what we did, we could not get them to chew.

Then, quite by accident, we had a shooting session with a just-maturing Great Dane type of dog that was still not out of the chewing stage. We quickly found him objects to chew and he performed admirably. For the balance of that assignment we made a point of getting young, immature dogs, and by patiently feeding them with a multitude of chewables we were able to get our pictures.

Here again patience paid off. Had I given up with the first few dogs, I would not have discovered the secret of how to get chewing pictures. From my experience with Kittydog, I should have realized that the "teenage" route was the way to go, but sometimes we don't think things out.

These are just a few examples of patience paying off in the studio. Out in the field where there is even less control of circumstances than in the studio, patience is mandatory. Take the shot of the lion roaring—actually, he's yawning. This was made after many hours of waiting for just such a lucky happening. Zoo animals—this shot was made at the Bronx Zoo—seem to live a very dull life.

After trying a half-dozen dogs to get one to chew, this one was the first to cooperate. Had we given up after the first six, we could not have completed our assignment.

Perhaps they like it; I doubt if anyone knows for sure. This magnificent beast looked bored. He'd sit and look out at the people; he'd take a nap, get up, walk back and forth, take another nap. Nothing he did was very picture-worthy. Since he was a member of the cat family, I said to myself, what would a cat do under similar circumstances that would make a good picture? Remembering that cats usually yawn when they wake up, this was what I was waiting for—but if anything else interesting happened I'd be ready for that, too.

Sure enough, after waking up from one of his naps, Mr. Lion gave me this tremendous yawn. So, here again, by being patient I was able to get a good picture. Certainly the picture of the lion yawning is a more appealing shot than the one of the lion sleeping.

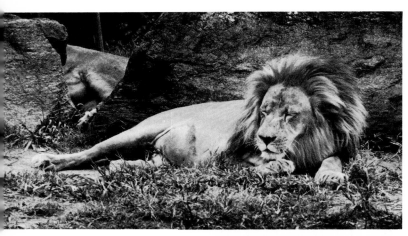

Out in the field or in a zoo, you need even more patience than in a studio. Because you have little or no control over either the animals or the light, you have to shoot things as they are. The sleeping lion is a cat. Cats yawn when they wake up. All I had to do was wait patiently until the lion was all slept out. When he woke up, he yawned, and I got my shot.

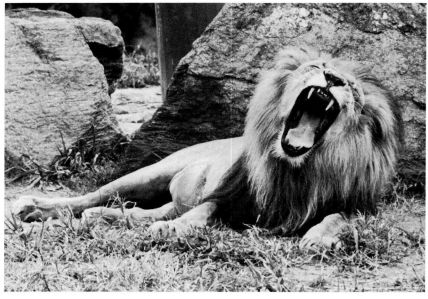

KEEPING A NOTEBOOK 8

IF YOU'RE A BEGINNING photographer, you are undoubtedly making many errors; if you aren't, you're either a fast learner or—more likely—you're not shooting enough pictures. Because photography is an exact science, when you make a technical error it can easily be corrected. But unless you know what you're doing —or what you've done—you'll not be able to make any corrections. So you have to keep notes.

Don't make the notes on bits and pieces of paper—keep a notebook. Given a film of a certain ASA rating, exposed at a given aperture and shutter speed, with a measurable light source and processed according to instructions, the results obtained can be duplicated years later if the same conditions prevail.

For outdoor shooting situations, your note-taking will be minimized. There are no great problems associated with pictures made in bright sunlight or in open shade. Backlighted situations might require some reminders. Remember the rule I mentioned earlier—for backlighted subjects, open up two f/stops from the normal full sunlight exposure. Example: ASA 25 Kodachrome film has a bright sunlight rating of f/8 at 1/125 sec. To backlight the subject on a bright sunny day— i.e., with the important face area in shade—open up the aperture two stops to f/4 at the same shutter speed.

The basic exposure for ASA 400 Kodak Tri-X film in bright sunlight is f/22 at 1/250. Say you have a cat in a backlighted situation, and you remember from your note-taking that you have to open up two stops. You speedily set your lens

Photography is an exact science. If you make technical errors you can easily correct them—if you keep a notebook. If you keep such a record, you'll know that the bright sunlight exposure for ASA 400 film is f/22 at 1/250 if your subject receives full sunlight. But if the subject is backlighted, you open the aperture two full stops to f/11. Put this down in your notebook and you may remember it better. In case you forget, it's there in your notes.

opening to f/11, shoot, and you have your picture. But no amount of reading about it here or in any other book will implant this fact in your mind. Go out right now and shoot a test to prove to yourself that this fact is accurate. With your *particular* camera, you may perhaps have to open up one stop or three stops because of an inaccurate shutter. So unless you make the test with the camera *you* use and make appropriate notes, this basic rule won't make too much of an impression on you.

Incidentally, when you make tests of any sort, keep the shutter speeds constant and vary the f/stop rather than the other way around. When you change an aperture from f/8 to f/11 with a given shutter speed, the amount of light reaching the film will be cut exactly in half. But if you leave the aperture at f/8 and change the shutter speed from 1/125 sec. to 1/250 sec., you really won't know if the exposure is being cut in half because shutters are notorious for being inaccurate. Leaf-type shutters tend to be less accurate than focal-plane shutters. So for any testing, vary the aperture rather than the shutter setting.

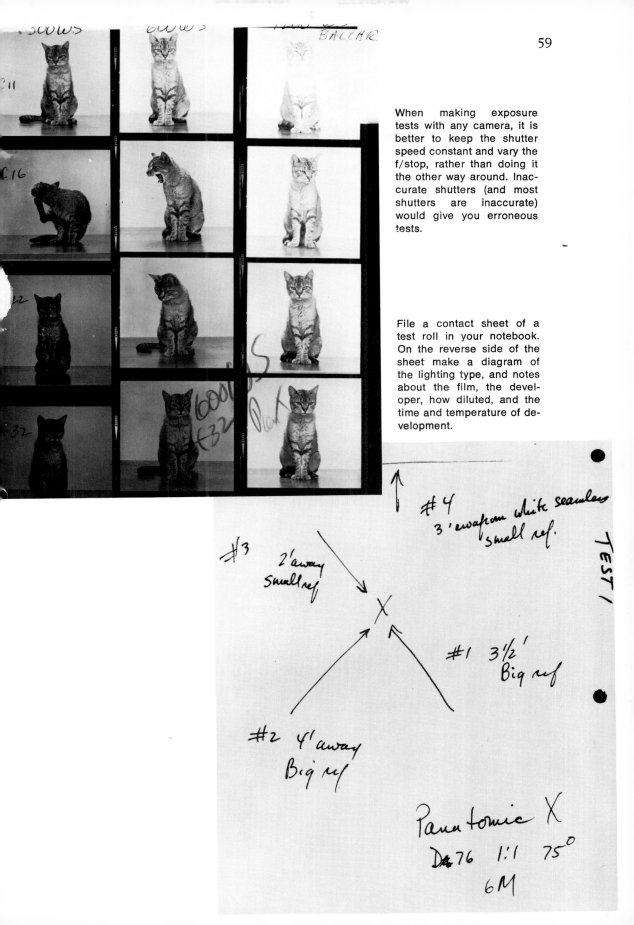

When making exposure tests with any camera, it is better to keep the shutter speed constant and vary the f/stop, rather than doing it the other way around. Inaccurate shutters (and most shutters are inaccurate) would give you erroneous tests.

File a contact sheet of a test roll in your notebook. On the reverse side of the sheet make a diagram of the lighting type, and notes about the film, the developer, how diluted, and the time and temperature of development.

When making test exposures of any sort, use a model that will remain relatively immobile throughout the test. An even better idea is to include in the picture area cards showing the exposure data.

Indoors with artificial light your note-taking will be more extensive. Flash guide numbers will be one of your many entries. The guide numbers supplied with the electronic flash units and flashbulbs are not always precise. I don't use flashbulbs too often, but they are good to have for emergency light when I travel, especially the tiny AG-1 bulbs. My tests indicate that with AG-1 flashbulbs in a folding fan BC unit shot at 1/30 sec. with my Nikon, the guide number should be 55 for ASA 25 Kodachrome film. The information on the bulb package calls for a guide number of 65, but a footnote says that if a folding fan reflector is used, the lens should be opened up one f/stop. My tests show 55 is a good compromise guide number.

I don't use AG-1 flashbulbs that often. As I said, they are mostly an emergency light. So to avoid having to make a test each time I anticipate using flashbulbs, I simply refer to my notebook and look at the test pictures. As an added reminder, before going on a trip I attach self-stick labels to the back of my Nikon camera that say AG-1 55 1/30. This tells me all I have to know about the intensity of the flashbulbs. Should months or even years elapse between the shots I make with them, my exposures will be accurate.

Supplement your written notes with actual photographs. Most professionals make frequent use of Polaroid film to make test shots. Saving these shots with the necessary information indicated on the back, and filing them in a notebook, makes it easy to repeat certain types of shots. When I get new lights or when I use a new and untried film, I make a test roll with several variations in exposure. Then a contact sheet is made of this test roll, and appropriate notes are put on the reverse side of the sheet. The sheet becomes part of my three-ring reference notebook.

For your day-to-day run-of-the-mill shooting, notes are not necessary—what you're doing is more or less a reflex. But keeping notes is useful for situations

I use flashbulbs as an emergency light, but infrequently. To remind me of their guide number I attach self-stick labels to my cameras reading: KII AG1 55 1/30. This instantly tells me that with Kodachrome II, the guide number at 1/30 sec. is 55 for an AG1 flashbulb in my fan reflector.

that are infrequent—like the circus. I've had several assignments to photograph the Ringling Bros., Barnum & Bailey Circus at Madison Square Garden in New York. Because a year elapses between Garden assignments, I'm especially careful to keep notes on the pictures I have made there. With the constantly changing levels of illumination in the arena, meter readings can be only a starting point. It's necessary to use a lot of judgment to get consistently good circus pictures.

During one of the first days the circus is in town, I shoot a test roll during a matinee performance, have the roll processed late that afternoon, and by the evening performance I have enough information on exposures to shoot for keeps. Most of the exposures on the test roll are fairly accurate, but when colored lights are used instead of white light, still more exposure is needed. As expected, the best transparencies are those made when the overhead house lights were on and combined with the spots.

All these facts are put down on a page in my notebook, as well as the type

of film used and how it was developed. Thereafter when I go to the circus, all I need do is refer to my notebook, and I'm ready to shoot.

Keep a notebook of everything you do when you are starting. You'll find, as your experience broadens your knowledge, that you will refer to your notebook less and less. But even if you refer to it only once a year and successfully reshoot something you've done in the past, the little time devoted to keeping notes will be worthwhile.

A year or more generally elapses between circus assignments. Each year before going to the circus, I refer to the notes I made on previous occasions. These, combined with some on-the-spot judgment, make it possible to shoot circus pictures from year to year without making new tests every time.

When making entries in your notebook, include 8×10 prints to remind you of lighting conditions. Center ring animal acts usually have lots of light, and so you get evenly illuminated pictures. Incidentally, always be prepared to shoot—the unexpected may happen at any moment, as it did here with this stretched-out paw.

GETTING ANIMALS TO COOPERATE

Now THAT YOU'VE LEARNED to cram useful information into your computer memory bank and to put it to good visual use—and now that you know what kind of equipment you'll need—you may wonder how to get animals to cooperate.

Animals are motivated by hunger and sex, and you'll use both these forces to get them to cooperate with you in your picture-taking efforts. And another trait that all animals possess to one degree or another—curiosity—will also be of help.

In your observe-your-pet period, before you started shooting pictures, I hope you noticed that sounds play an important role in the life of animals. Cats and dogs (and most other animals) are keenly aware of the sounds about them—much more so than human beings are.

Observe your dog in the middle of a quiet, cold, snowy winter evening—it's so still you can hear a pin drop. Yet your dog, who was peacefully dozing on the hearth, is suddenly wide awake. His head still rests on his paws, but he opens his eyes and surveys the room. His ears twitch ever so slightly. Then, to get a better reception of whatever he's receiving, his head will come up and maybe turn one way or another. He hears something, yet you can't hear a thing. If the sound goes away, he'll resume his nap; if it persists, he'll probably start barking and ask to be let out to investigate further. Yet you heard nothing.

Or take the case of a cat we once had named Loco. Promptly at eleven o'clock every night Loco would race around the outer periphery of the three

Animals are motivated by hunger and sex, and both these drives are used to get photographs. I don't know if it was the mating season for these penguins, but the way the one followed the other around indicated some sort of attraction between them.

rooms of our apartment like a creature possessed. Then, just as suddenly as the racing started, it would cease and he'd go back to being his sweet, lovable, normal self. Why did he do it? And why did he do it at exactly eleven o'clock at night? The only explanation I have is that he heard a sound that was inaudible to us—possibly a factory whistle or maybe even a train or boat whistle, since we lived on the fringe of a waterfront/industrial area.

Sounds play an important role in the life of animals. They are more keenly aware of the sounds around them than we humans are.

A high-pitched whimper—the kind of sound a crying puppy would make—is especially effective in getting a dog to give you a quizzical, head-cocked-to-one-side pose.

When peacocks mate, the male spreads his tail feathers, ruffles them, and attempts to get the female cornered. So all you need do to get a good peacock picture is wait until the male feels sexy.

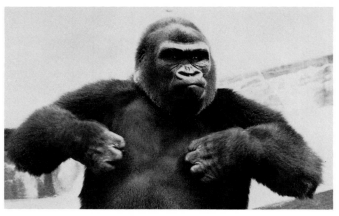

Even zoo animals will respond to sounds. This gorilla would beat his chest when a human spectator friend clapped his hands and said, "Mambo, beat your chest."

Obviously, since animals are so responsive to sounds, these will be your primary devices to evoke a response. And, surprisingly, the sounds they respond to best are those that are made by humans but that have animal overtones—meow, bark, moan, growl, chirp, sigh, cough, bleat, caw, whinny, gobble, grunt, moo. Make any kind of noise that will get an expression or pose from your subject.

One of my favorite sounds when I'm working with either cats or dogs is a sort of high-pitched whimper much like a young puppy would make. Although it is what we would consider a "dog" sound, cats respond to it just as much as dogs do. It is an especially good sound for dogs when you're looking for one of those quizzical, head-cocked-to-one-side poses that are so appealing.

Usually the vocal sounds that you or your assistant makes will get some kind of favorable response from the animals. But if they just sit there ignoring you, don't despair. There are other sounds that are reliable with some models. Squeak toys made of rubber or plastic are very effective. For years our children could never have the pleasure of prolonged playing with these squeeze-squeak toys. No sooner would they get a new one than we'd appropriate it for use in the studio. When dogs get playful, they puncture the rubber and the toys lose their squeak—hence, the constant need for a new supply.

Another handy sound-maker that photographers usually have is empty 35mm film cans. Half-filled with objects of different densities, these will produce a variety of sounds. Put some pennies in one, a handful of rice in another, several marbles in another, and you'll have a whole array of sound-makers. These cans can be shaken at camera position or, if you want your subject to look off into the distance, toss a couple of them over your shoulder; as they bounce off a wall behind you, hopefully your subject will look toward the sound.

Another sound—a non-vocal one—that is good for cats and kittens is the quiet, subtle sound created by rubbing your thumb across the tip of your other fingers. Try it now as you read this—put your fingers up to your ears and rub. I figure that a cat thinks this sound is made by a mouse. But whatever he figures doesn't matter. That he is alerted by it is all you want.

Still another one they liked is the crinkly noise made by crushing an empty pack of cigarettes. I say *liked* because I haven't used this gimmick since I quit smoking a few years back. Another sound I no longer use but that was very effective was to run my fingernails along the corrugations on the inside of a flashbulb

A handy sound-maker, available in most studios, is an empty 35mm film can into which you can put a couple of pennies, some pebbles, or other small objects that will rattle. Thrown where you want your model to look, such a can makes just enough noise to get the desired result. *Used by special permission of General Foods.*

A non-vocal sound that will attract cats and kittens is the quiet, subtle noise made by rubbing your fingers together. It's just loud enough to arouse a cat's curiosity. *As published by The Merrill Company.*

sleeve. When speedlight replaced flashbulbs, we no longer had empty sleeves handy. If you want to try the effectiveness of this sound, you can use the sleeve from a lightbulb.

Another good reason for using the twin-lens Rolleiflex for animal photography is the sharp rattling sound you can make by banging your fingers on the focusing hood. Many, many of my animal photographs with good alert expressions were obtained by using the "Rollei rattle."

All the sounds mentioned above have been used successfully—and on other occasions they were complete failures. Try them, and if they work use them over again. If they don't work, make up some of your own—improvise. Keep in mind, however, that whatever sound you use you should try to keep it subtle. Sharp, sudden explosive sounds may scare your subject.

Although they are called dumb animals by those who don't know any better, animals are pretty smart. They're certainly smart enough to know, after their initial curious response, that the sounds you're making are nothing to be concerned with. This is why you need a whole range of sounds. When one is no longer producing the desired result, switch to another, then another, and still another.

One sound at a time by one person at a time is a rule in our studio. If different sounds are being made simultaneously in different parts of the room, you will not know which way your model will turn. One sound at a time, and you're in control.

One sound at a time made by one person at a time is a rule in our studio. Picture this: a magnificent dog on the set—I'm behind the camera, my assistant is on my right, one of the dog's owners is on the left, and his wife is sitting in a director's chair on the far right. The dog is not cooperating. I try some sounds; my assistant tries some sounds at my suggestion, and we begin to get cooperation. Then the owner on the left makes a sound, and the dog turns in that direction—and his wife makes a sound, and the dog turns in *that* direction. What confusion results! After everybody quiets down, we get back to shooting pictures properly.

The sex drive of a cat can be used to your picture-taking advantage if you know how to sound like a sexy cat. If you've ever heard a couple of cats courting, you know it's not the most subtle lovemaking in the animal world. Caterwauling is what it's called. Since these moaning-meows are made by both the male and the female, either sex will sit up and take notice when you duplicate the sound of a cat in love.

With horses and cows, the introduction of a member of the opposite sex will usually get an alert reaction from the one you're photographing. And to a lesser degree dogs will also fall for the sexy-siren-on-the-sidelines gimmick.

Working on the hunger drive of animals is also useful at times. (When I say hunger drive, I don't mean starving an animal in order to get it to cooperate.) What, after all, do most animals live for but food and sex? And with most of them, most of the time, it's in that order. I didn't realize how effectively food could be used to get animal cooperation until my recent in-depth exposure to horses, while working on my *Book of Foals and Horses*. Before working on the book, I always thought my inability to induce a horse to go to a given location

was due solely to my lack of knowledge of the horse, plus my healthy respect for his size.

There were times when a picture would be improved if the horse was located in another part of a pasture. But any stunt I tried to get him to move was unsuccessful—and in many cases so were the owner's efforts until he used the old oats-in-the-bucket trick. When horses hear the sound of oats being shaken in a bucket, they come a-running. Even Babbo, our erstwhile New York City police horse, found the oats-in-the-bucket trick irresistible. The minute he heard the sound of rattling oats, he'd come as though drawn by a magnet.

A horse will respond to the oats trick even though he has eaten barely a half-hour before or even as he's grazing in a pasture. Dogs and cats will also respond to a tasty morsel even though they've recently eaten. This is why I say you can use the hunger drive of animals to get them to cooperate. Our cats will always respond when bribed with shrimp or cheese. Dogs usually go for a liver snack, cheese crackers, hot dogs, or sardines (they're a little sloppy); potato chips are also big with dogs, as are salted nuts. Cats are crazy about liverwurst. The snack should be something your model likes but does not get too frequently.

Until I learned the old oats-in-the-bucket trick, I was completely baffled as to how to lure horses from one place to another. The sound of oats sloshing in a tin bucket is irresistible to even the most well-fed horse.

Most animals will respond to food—particularly a special snack that they like—even though they have just eaten. Bribing them with a favorite food is using their hunger drive to your advantage.

Say you want to shoot a cat leaping in mid-air from one point to another. Here's how to do it: Place the cat on point A, give him a tiny bit of his favorite snack—maybe it's Cheddar cheese. Then place a piece of the cheese at point B, and indicate to the cat that the cheese is there. Let him eat it. Put the cat back at point A, put another piece of cheese at point B, but this time move B farther away from A. The cat will easily leap from A to B to obtain the snack. Keep repeating the process until points A and B are sufficiently separated so that the cat must take a healthy leap to get his snack.

To carry this experiment still further introduce the element of sound. Next time you're in a 5 & 10 cent store buy a clicker, one of those thumb-sized gadgets made of a piece of metal and spring steel that, when pressed together, makes a clicking sound. Now when your cat bites into the piece of cheese at point A, click the clicker. When he goes to point B to eat the cheese, click the clicker. Repeat the cheese-clicker routine several times, and before too long you'll find that the cat will go from point A to B *only* when he hears the clicker. What happened? Each time he bit into his favorite snack he heard a click. He learned that the click and his snack were closely related.

Let's get back to cat pictures. You have to get a sensational mid-air shot of a cat leaping. After you've conditioned your cat, the shot is a cinch. Place him on point A, place point B about four feet away, and prefocus your camera at some mid-point. You're all set. Your assistant makes a click at point B. The cat thinks of cheese, makes a spectacular leap, and you get a sensational picture. Just to keep your cat happy, you ought to reward him with a double portion of cheese for being so cooperative. If you *have* to make a picture and you're out of cheese, you can use only the clicker, but if you have the cheese, why not keep him happy?

It's easy when you know how. I cannot, however, take credit for this conditioned-reflex technique. A Russian physiologist, Ivan Pavlov, many years ago discovered that dogs would salivate when an artificial stimulus (a bell) was used as a substitute for a natural stimulus (food). By simply applying Pavlov's research to a photographic problem, we can get a picture without a lot of anguish.

You'll recall that in the opening pages of this book I mentioned your mind computer and how you must constantly stock it with bits and pieces of information as part of your creative development. When I first read of Pavlov and his experiment, I had no idea that this bit of information would be helpful in making a photograph. And though I made no conscious effort to store it in my mind memory bank, there it sat all these years. Then one day I had to make a picture of a leaping cat, and Pavlov came to the rescue.

So, I repeat, to be creative—read, read, read, read. Read everything, read everywhere, read all the time. Read newspapers, magazines, books, brochures, ads, billboards—everything! Absorb everything around you—be observant, and learn to make mental pictures of the things you see every day. Cram your mind. Then, as you evolve and develop into a top-notch photographer, you'll find your mind computer to be retrieving information that you stored in your memory bank many years ago. From Pavlov to computers is quite a jump, but the importance of absorbing information cannot be overstressed.

Next, suppose you want to get a picture of a dog licking his chops, for an advertisement for a dog food company. Most dog food companies have used a picture of this type at one time or another. Pictures of dogs actually eating tend to get pretty messy, so as a relief from the sloppy eating pictures some advertisers like to show the clean-up after eating, the dog licking his chops. I think the idea is that the dogs like the food so much that they want to absorb every last morsel of it, and so they lick their faces clean.

But the problem is that not all dogs will lick their chops. To encourage cooperation, first feed your model a good-sized portion of his regular dog food to take the edge off his appetite. He may now lick his chops and you'll get your shot. If he doesn't, rub some bacon grease on either side of his mouth. He'll like the fat so much that he'll lick like crazy. And it will be good for him. Many professional breeders regularly add bacon fat to the diet of their dogs; it's supposed to make their coats slick and shiny.

To recap on getting animals to cooperate: you have two things going for you—the curiosity of animals and their response to sounds of all kinds; and their constant preoccupation with food and eagerness to gulp down any tasty morsel that they regard as gourmet fare.

Using Pavlov's theory of conditioned reflexes made it easy to get this shot of a leaping cat. He had been taught to associate the sound of a clicker with food. *Used by special permission of Pellon Corporation.*

It's easy to get a dog to lick his chops. Feed him until he's full, and after he's finished eating he'll lick the residue from his mouth area. A little bacon fat rubbed on his chops will serve as an added inducement for licking.

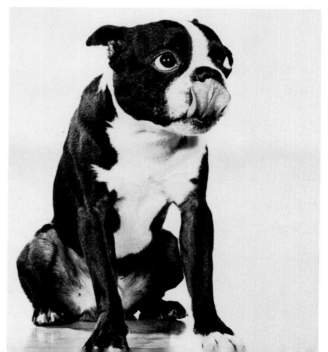

10 SHOOTING TECHNIQUES

ONE OF THE QUESTIONS I'm asked most frequently by amateurs at camera clubs is: How many exposures do you make to get a good picture? A good question, but one that has no pat answer. Generally I make as many exposures as I need to get the desired picture. It could be just a couple of shots or it could be several dozen—it depends on the shot. In almost all cases, the preparations prior to shooting are far more time-consuming than the actual picture-taking. Take the shot of the leaping cat—the training took weeks, but the shooting of a dozen or so exposures was done in 20 to 25 minutes.

Now take the shot of the cat licking its chops. The procedure was exactly the same as described for the dog, but on a shot like this I might have to make two or three dozen shots, primarily because of the lack of precise timing between when the cat licks and when I release the shutter, i.e., I may be shooting too early or too late.

The contact sheet shown here clearly indicates why it's necessary to shoot multiple exposures on this type of picture. Note that many of the pictures on the contact sheet show little indication of what we're supposed to be getting—a cat licking its chops. In trying to anticipate the action, I released the shutter prema-

One of the questions I'm asked most often is how many exposures I make to get a good picture. Sometimes, of course, I don't get a chance to make more than one shot. But in studio situations I can generally expect to obtain the desired shot in a roll of twelve exposures.

►

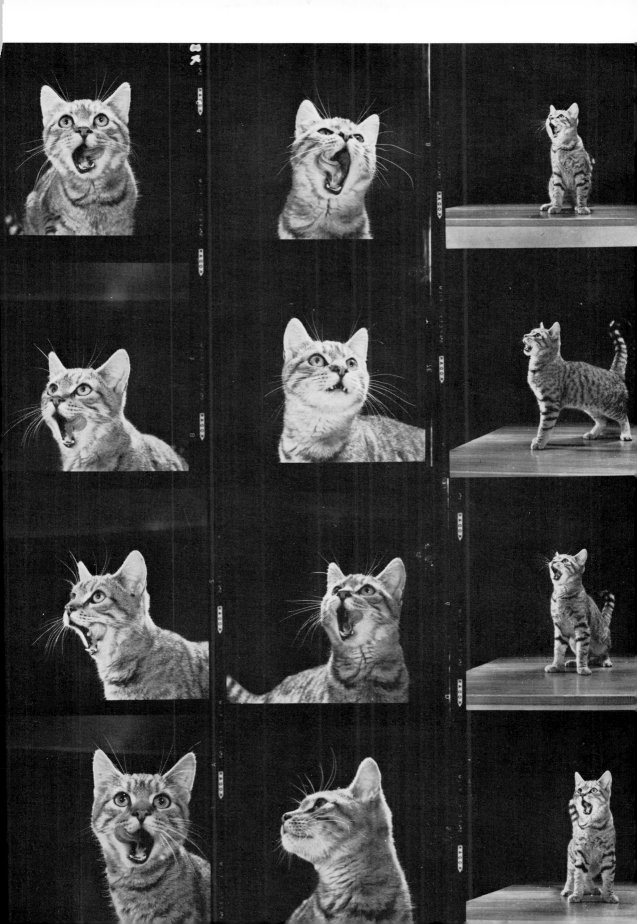

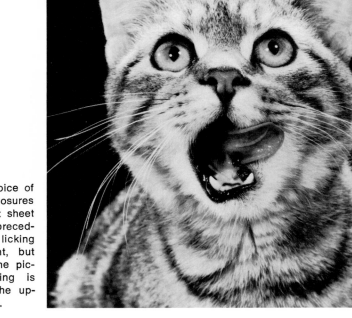

This is my choice of the twelve exposures on the contact sheet shown on the preceding page. The licking action is right, but what makes the picture outstanding is the eyes in the up-raised position.

turely. Some shots were made too late—maybe 1/1,000 sec. too late; the degree of lateness does not matter. The pictures are not right. A couple are pretty good but perhaps too clinical—too much of the tongue on the inside of the mouth can be seen. My choice is shown in the next illustration. It has the right action, but what really makes the picture are the eyes in the up-raised position, as though the cat is asking for more of those delicious fresh-from-the-sea Sea Snacks, "the preferred snack for cats."

Sometimes just a single shot is all I can get. Generally this occurs when an animal will do something just once, and no matter what you do, you don't get a second chance. The wide-eyed Weimaraner is a case in point. This dog was brought into the studio to get some straight Weimaraner pictures, nothing spectacular. In the course of the shooting he sighted one of our cats, and the startled expression was his reaction. I knew I had a great shot in that one exposure. Quickly the cat was taken out of the studio and then reintroduced a few moments later, but nothing happened. The initial surprise or shock was gone. Had the dog continued to react as he did initially, I would have continued shooting.

One of the basic tenets of professional photographers is that film is the least expensive item of their many expenses. To say it another way: film is cheap; use as much of it as you think necessary to get the desired picture. If film is not used, pictures are not made—it's as simple as that.

However, this does not mean that dozens of exposures should be made of the same situation without attempting to achieve any variety. There is absolutely nothing to be gained by shooting 36 almost identical pictures without any variation in pose or expression or lighting. Admittedly, some professionals use such a shot-gun technique in the hope of coming up with one good shot. But at the other end of the scale are the many press photographers who will make but one or two exposures of a situation, and confidently process and print—and get pub-

No second chance on a shot like this. We were shooting conventional magazine cover pictures with this Weimaraner when he spotted one of our cats. The wide-eyed expression was the result. When we tried a retake, nothing happened—the surprise was gone.

Film is cheap. Use as much of it as you think necessary to get the desired picture. This does not mean, however, that dozens of pictures should be made without some variety of pose, expression, or props.

◄

There are times when some of my pet food clients don't know exactly what they want, so we experiment a bit and give them different concepts, different lighting, different breeds. The end result is a greater choice for the client. *Used by special permission of Ralston Purina Company.*

lished—a high percentage of what they shoot. Somewhere between these two extremes is a happy medium of my kind of animal photography. I rarely take just one or two shots of a given situation, and I've *never* taken more than 3 or 4 rolls of 12-exposure 120 film to get a required shot.

Exception: Suppose you just want to make a great many different pictures of cats in the hope of coming up with an outstanding shot for a contest or a camera club exhibition. Then by all means shoot a lot of film. Keep shooting pictures of your cat in every conceivable pose and situation—shoot, shoot, shoot. The more pictures you make of *different poses* and *different situations,* the greater will be your chance of coming up with an outstanding group of pictures. But note that you will not be burning up a lot of film shooting the same thing over and over again.

There are occasions when an advertising agency or a design studio for a pet food account will ask me for pictures, but they don't know what they want. So we experiment with different models, different lighting, and different situations. The result is that the client has many pictures to choose from and is not locked into just one concept.

I also shoot many rolls when I am working on pictures for a book or a calendar. The contact sheets on pages 78-79 were part of some experimental shooting I did to illustrate my *Book of Kittens and Cats.* I made pictures of the cats all day long, just following them about and shooting when I thought they were in a good picture situation.

On the other hand, when I have a specific situation such as the kitten peek-

Two of the many experimental contact sheets I made when preparing my *Book of Kittens and Cats*.

79

Modules galore!

Modules galore!

This is the EG&G layout and the finished ad. Even though the concept was limited, we were able to give the ad a little zip by getting the kitten to bring its paw around to the front of the module. *Used by special permission of EG&G Inc.*

◄

When locked into a single concept, as in this ad where the client simply wanted a kitten peeking around a computer component, a roll or two of film is more than adequate to cover the situation. The contact sheet shows the variety of poses and the shot selected.

ing around a computer component, it would be wasteful to do too many shots. The situation is a static one. The art director wanted a shot of a kitten peeking around the components, period. How many variations of such a shot are possible? A couple of rolls and the shot is done. That the kitten may have had a nap and been fed in the course of the shooting session is beside the point. As long as we get model cooperation we shoot, and if they don't cooperate we try to figure out why. Kittens and puppies tire very easily and require frequent naps. If they begin to tire, we quit shooting, let them take a nap, and resume when *they're* ready to resume.

To get a higher percentage of good usable pictures, you have to have a quick trigger finger. And just as the ability to visualize can be acquired, I think you can develop your timing to a point where you can have the fastest trigger finger in the West—or the East—or wherever you live. A quick trigger finger or a quick shutter finger is another way to describe timing. Here's the way it works. You have a situation where you must shoot fast to get some peak action, like the dog leaping over the sawhorse. The only way to shoot this shot is to get the dog at the peak of his leap. The dog runs, leaps, and is over the hurdle faster than you can read this sentence. You shoot when the action is at its peak.

Your eye sees the dog through the viewfinder and sends a message to your brain, which in turn commands your trigger finger to release the shutter. If your reaction time is fast, you'll get your shot; if you hesitate, you'll miss. What you want to do is develop this reaction so that you shoot when the action is right— not too soon, not too late.

A quick shutter finger is another way to say quick timing, which means catching action at its peak, as in the case of this Dalmatian leaping over a sawhorse. Good timing can be developed through practice. Incidentally, always look for a picture within a picture. Originally, this shot was made for a story on dog training; hence, the presence of the boy in the picture. But by cropping the boy out, we got another peak action shot of the dog alone.

Here's how to develop your timing. Let's assume you're driving over to the local emporium to buy some supplies. You're on a road that has numerous traffic lights. Your two hands are on the steering wheel. Pretend you're holding a camera instead of a steering wheel and your shutter finger is poised on the release button. You stop the car for a red light. Now pretend that the instant the light turns green, you're supposed to shoot some peak action. You know it's going to turn; the point is to shoot when it does. The instant the light turns, "shoot." As you drive down the road repeat this process, making many imaginary shots.

Suppose your destination is a supermarket. As you wheel your shopping cart through the aisles, shoot imaginary pictures of various scenes. The exact instant another shopper reaches for a can of corn, for instance. When the hand is on the can, "shoot." Then make another "shot" when the can is being placed in the cart. At the checkout counter, take a "shot" of the clerk counting out change into the outstretched palm of a customer in front of you. "Shoot" at the exact instant the clerk is about to place a paper bill in the customer's hand.

When you're at a movie or watching TV, do the same thing. Say you're watching a Western and there is a shoot-out at high noon. The instant the hero goes for his gun, "shoot" your imaginary shot. Try to shoot before he does!

You've seen numerous photographs made by press photographers of prominent people behind a podium pompously politicking—especially in election years. These are usually dull assignments. But a good photographer will look for something to take the picture out of the ordinary—some gesture with the hands or a facial expression—a frown, a grimace, a wink, a grin. When a good photographer sees something other than Mr. Big as we all know him, a quick shot makes the picture that's in all the papers the next morning.

This is your assignment the next time you're at home watching a political speech on TV. Use an unloaded camera and watch the speech through the view-

Your timing can be developed and sharpened by constant practice with and without a camera. Every day, everywhere you go, you can practice "shooting" even though you have no camera. Then when you do shoot, your good timing will enable you to get a shot like this. *As published in* American Weekly *magazine.*

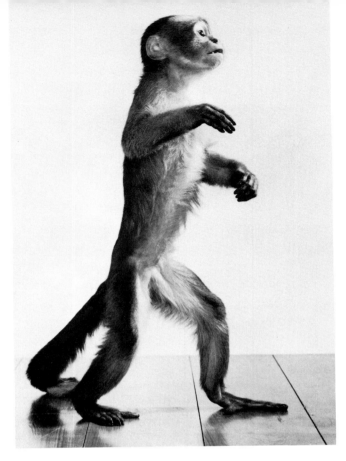

Having a quick trigger finger is an advantage for fast-breaking action. Unusual body positions, facial expressions, and gestures are bits of action that, when timed right, make or break a picture.

finder. When something different occurs, "shoot." See if you can shoot *the* picture that will be in the newspapers the next day.

To keep your timing sharp, you should make these practice sessions a habit. I still do, to keep my quick shutter finger. When I'm out walking on a country road and a rabbit scoots out in front of me, I press my thumb against my index finger to simulate releasing a shutter. A pheasant makes a startled ascent, and I try to get a "picture" of it. If I'm walking in the city, I try to see pictures and pretend I'm shooting them. When I see a bus approaching a curb to discharge passengers, I try to get a "picture" of one as he is about to step off—one foot hitting the pavement but the other foot still on the step.

You get the idea. Only by continually practicing this imaginary shooting will you be able to sharpen your timing.

Being able to shoot fast makes the difference between getting just good shots and sensational shots. The pictures of the five kittens shown here are a good example of split-second timing. The picture of the kittens just sitting and posing is a pretty good shot considering the problems allied with getting five squirming, playful models to stay in an even line of focus. It's a good picture. But the other shot of another five kittens is sensational. Each kitten is doing something different—and each contributes something to make it the great shot it is. You may have seen big color prints of this picture as part of a Kodak display in camera stores.

To get this picture of the five kittens required fast shooting—a quick trig-

To get five kittens just to sit and pose is a feat in itself. But to get them all simultaneously engaged in some sort of subtle action requires more than just a quick trigger finger. By anticipating the action, this Kodak photograph was turned into a great shot. *Used by special permission of Kodak.*

A good shot, but it doesn't have the playful action of the five Kodak kittens. Always look for the unexpected when shooting groups of animals.

By anticipating the minor action of the kitten's lifting its paw, I was able to give the art director of this ad a photograph that suggests the cat's eagerness to get to the food. *Used by special permission of Star-Kist Foods, Inc.*

The layout of the 9-Lives Cat Food ad was improved by having the cat face into the picture rather than out, as originally sketched. *Used by special permission of Star-Kist Foods, Inc.*

ger finger. But it wasn't the only factor involved. *Anticipating the action* is the other big factor.

This was an especially playful litter of kittens, and at first I figured I might get some interesting pictures of them. Then, frankly, from the way they were playing, I wondered if I'd get any pictures at all. Finally, as they began to tire, their actions were not so quick. Then I saw what seemed to be working up to a good shot when the kitten in the middle got up on his hind legs. I knew he'd have to come down, and since he was in a playful mood, I figured he'd probably pounce on one of his siblings as he descended. So just as he started to come down, I shot—and as the message was going from my brain to my finger, I noticed the other two cats smiling!

By anticipating that something was about to happen, I shot when I saw the beginning of the situation. Had I waited until I saw the peak action to make the exposure, it would have been too late. The action would have passed.

Sports photographers get their best pictures by anticipating action, as do photojournalists. As an animal photographer, you'll have to do the same. But

only by knowing animals and their actions will you be able to take full advantage of the anticipation factor.

In animal photography there are not too many sensational high-peak action situations. They run, jump up, down, or over—and that's it. But sensational action is not all there is. An upraised paw, a grimace, a big meow, an unusual body position—these little actions also need to be anticipated.

The picture of the kitten playing with the canopener in the 9-Lives Cat Food ad is a good example of anticipating a small action. If the kitten was just sitting alongside the can opener, the ad would not be nearly as effective as it is with the kitten's paw on it. The kitten was in a playful mood, and the can opener was a play object. By anticipating when he was about to raise his paw, I was able to get my picture.

The peak action of the child running with her leashed dog is an example of the other end of the action spectrum—good fast movement. A picture like this requires very little anticipation. The child is running back and forth with the dog; you know what the action will be. More than anything, on a shot like this you need a good fast shutter speed—1/500 sec., at least. And if the action flows parallel to your camera, 1/1000 sec. will give your picture greater sharpness.

Suppose you don't have enough light or your film is too slow to use a shutter speed of at least 1/500 sec. The solution is easy—pan your camera. When you move your camera (panning) at about the same speed as your subject, you can get by with a shutter setting of 1/125 sec. and still get your subject fairly sharp. A blurred background will result, but this will further enhance the illusion of sharpness. This panning technique is a good way to render a cluttered background harmless.

Still another device used by professional photographers to create the illusion of action is the blurred image. Sometimes the blurred-action pictures you see

With fast, sustained action, there is little need to anticipate where or when the action will occur. Whether it is the finish of a horse race or a child running with her dog, the action will take place at a point that is fairly certain. All you need is a fast shutter speed. Action parallel to the camera needs a shutter speed of 1/1,000 sec.

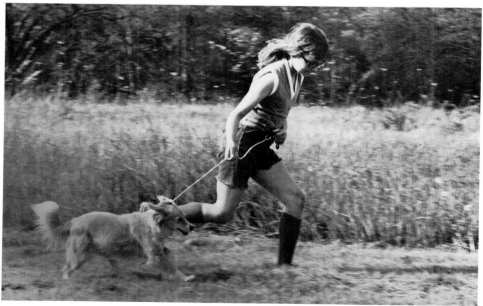

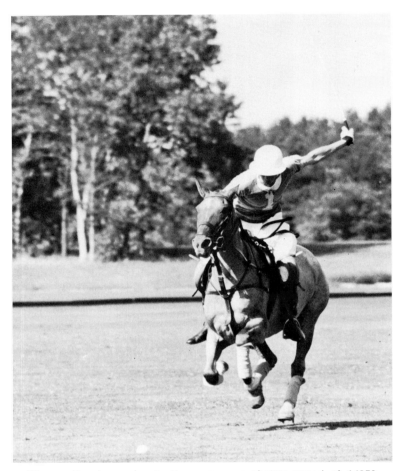

When action is coming to the camera, a shutter speed of 1/250 is adequate to get a good shot.

published were intended to be blurred, and other times they are fortunate accidents. The blurred image can be accomplished in several ways. Use a slow shutter speed on a fast-moving subject, and you'll get plenty of blur. If you want both the subject and the background to be blurred, use a slow shutter speed—1/30 sec. or even 1/15 sec.—and pan your camera during the exposure. You can get some interesting variations in blurs, especially on color transparencies, by giving the camera a circular twist while panning.

The pictures accompanying these pages show the various techniques of action photography. The polo pony coming at full gallop toward the camera was made at 1/250 sec. The girl running full speed had to be taken at 1/1,000 sec.

The reason the polo shot could be made at 1/250 sec. and still be sharp is the direction of the action. Action coming toward you doesn't need as fast a shutter speed as action that is parallel to the camera. The Labrador retriever leaping in the field was made at 1/250 sec., but the camera was panned to get image sharpness and background blur. The trotter was deliberately shot at 1/25 sec. *and* panned to get subject and background blur.

The camera was panned to follow the dog. The 1/250 sec. shutter stopped most of the action, only slightly blurring the background.

To get both subject and background blurred, set the shutter at 1/25–1/30 sec. and pan the camera when you shoot.

GETTING MODELS

Now THAT YOU KNOW the techniques of photographing animals, you'll have to find some animals to photograph. As an aspiring animal photographer you like animals—right? And presumably you have an animal or two of your own—right? Start your animal photography with your own pets.

My first serious efforts at animal photography were with my cat Loco. My "studio" was a three-room apartment just outside New York City. Loco was my prime model. He was very tolerant of my camera. There wasn't a spot in that three-room apartment where he could sit, sleep, eat, or play where he was safe from the inquisitive lens of my Rolleiflex. One of my most widely published picture stories was of Loco fighting his own image in a mirror.

But Loco had his limitations. He could take me only so far. If I was to build up the biggest stock file of cat pictures in the world, I would need something other than pictures of just a gray cat.

Actually, I had not even begun to exhaust the picture possibilities of Loco. Photographing just one cat, differently, can be a lifetime project—certainly a cat's lifetime anyway. Someday when time permits I will do just that: photograph a cat every day throughout his lifetime. The resulting photographs will make a fascinating book: a project for the future.

Getting back to Loco. Although I made many pictures of him, there were still many unexplored picture possibilities. Since then, I have never made as complete a variety of photographs of one cat. In those days, I was able to channel

When photographing horse races of any kind, don't make sudden moves as the horses approach your position—you may scare them. All your motions around all animals should be slow, quiet, and deliberate.

This type of photograph should not be attempted without a couple of assistants. Their job is to keep the animals in place; your job is to be alert, and when all the models are right you shoot—and shoot fast. You may not get a second chance!

High-speed strobe lights make action pictures like this easy. All you need to do is prefocus at about the spot where you expect the action—then shoot at the right time.

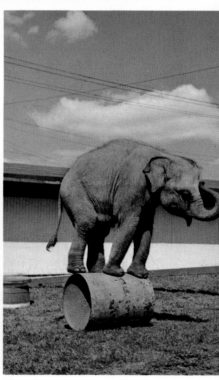

The circus is an excellent place for animal pictures—either during an actual performance or during a rehearsal in winter quarters.

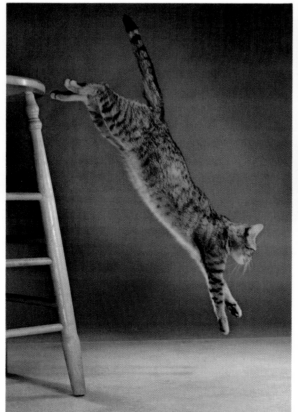

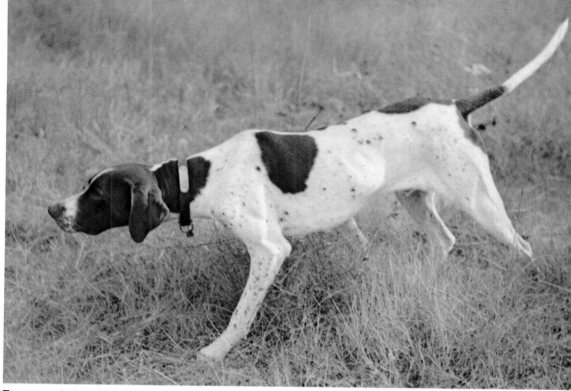

To get a photograph of a dog on point, you have to be patient. Sometimes you have to follow him for miles before he picks up the scent of a bird and freezes into a point.

If one animal makes a good picture, usually two of them together will make a better one. And if you want to push your luck, try three or more.

Zoo animals can be photographed so that they don't look like animals in a prison. Telephoto lenses are needed to get a fairly large image on your film.

Knowing the habits of animals can help you get good pictures. When a peacock gets the urge to mate, he will fan out his tail to show off his masculinity to the love of his life. He also uses the tail to back her into a convenient corner.

Common domestic fowl can be good subjects, and they are more readily available to most photographers than exotic wild birds in their natural habitat.

Wild animals are best photographed in their natural habitat. However, if you find one that is "domesticated," don't pass up the opportunity to make some closeup studio shots.

By constructing a blind at a salt lick, water hole, or feeding grounds, you can get close enough to wild game to get good photographs with a short telephoto lens.

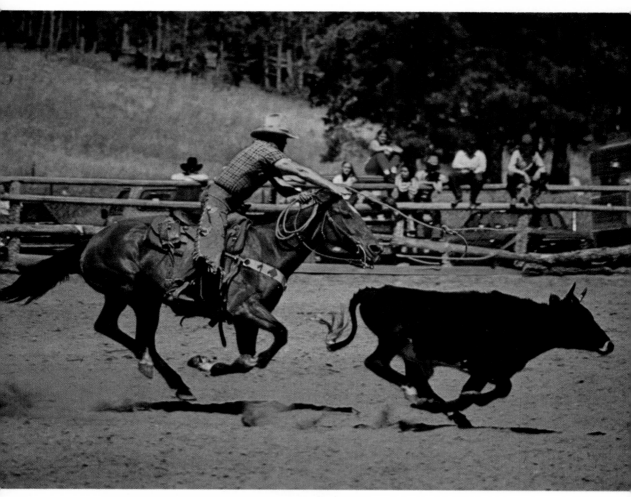

High-speed film and high shutter speeds are essential for good rodeo photographs. The action is fast; you'll need at least 1/250 sec., but 1/500 sec. will be better for most action.

By committing a few basic exposures to memory, you won't have to rely on a light meter. The basic full sun exposure for Ektachrome-X is f/8 at 1/250 sec. If the subject is back-lighted, open up two f/stops—in this case, to f/4 at 1/250 sec.

To get large sharp images of small creatures, you need supplementary closeup lenses or extension tubes. The use of a micro lens will give you close-ups without any extra attachments.

The most effective photographs—of animals or people—are those where the subject has direct eye contact with the viewer. This is achieved by having the model look directly into the lens.

Small kittens—and puppies too—tend to be very active. Isolating them by elevating them on a table or chair will usually keep them from getting out of camera range.

The best place to start your search for animal models is right in your own home. My first serious effort at animal photography was with my cat Loco. This picture story (here and on following pages) of Loco fighting in the mirror has been published all over the world.

all my efforts to making photographs of him. Today I hardly have time to make pictures of *any* of our house pets. There are too many other urgent, pressing things to do.

My point in mentioning Loco is that you should start your animal photography with a model close to home, preferably your own pet. It is convenient. It is available. And presumably compatible to you. You'll make lots of mistakes at first—and what better place to make your mistakes than at home, with your own model? You can discard your mistakes, and no one will be the wiser and your ego won't be deflated. Expect to make mistakes. Don't feel disheartened by them, but learn even from your earliest efforts.

A small digression here about mistakes. As a beginning photographer—or even as an experienced one—your best ego-building piece of equipment should

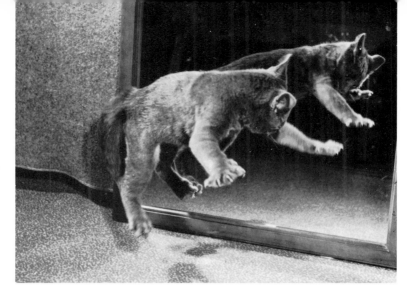

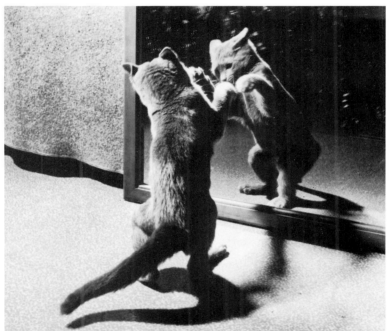

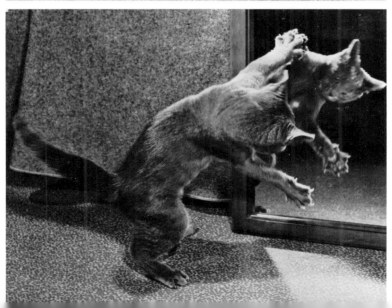

Although pictures of one of your models might be good technically—sharp, well-lighted, and properly exposed—that's not enough. Look for expressions or poses that are out of the ordinary. Out of the ten shots on this contact sheet, only one—top left—is outstanding. Tight cropping emphasizes the suspicious eye.

➤

The suspicious eye turned to the viewer makes the difference between an ordinary shot and an outstanding one.

be your wastebasket. You will never be judged by the pictures you throw away. If you could see the wastebaskets of the world's top photographers, you'd be amazed at their discards. The greater the competence of the photographer, the more critical he is of his own work. A pro is more likely to discard a large percentage of his take than a hack or an amateur. He is extremely critical of his own work—that's why he's on top. A professional who is a hack—and there are many—tends to make excuses for mediocre work and delivers what should have been discarded.

The contact sheet of dog photographs shown here is a case in point. All the pictures are good technically—they're sharp, well lighted, properly exposed. But that's not enough. I look for expressions that are different, and the shot I chose

After you've done a lot of pictures of your own pet, try pets belonging to your neighbors and friends. Then try cats and dogs together. They are unpredictable, and the unpredictable usually makes for interesting pictures.

is the "difference" shot. Cropped tight, with emphasis on the eyes, the picture is a stopper.

If you have *any* doubts about a picture you've made, throw it in the wastebasket. I repeat: *you'll never be judged by the pictures you throw out.* No one but you and your garbageman will ever know about them. When you show the few pictures you've saved, the accolades you get will be worth the extra time and expense you went through to make a good picture. Later, as you acquire more skill in handling the camera and in darkroom techniques, you may even discard some of the pictures you thought were good earlier in your career. That's fine. It indicates your attitudes or your techniques are active and changing. You will not stagnate photographically if you accept change.

So much for mistakes; back to models. After you've done as much as you can or care to with your own Fido or Tiger, look around your neighborhood for other potential subjects. If your own pet is a cat, look around for a dog, or vice versa. Shooting another species will give you more experience. Next try a cat *and* a dog together.

When springtime comes, kittens are usually born in great numbers. Let it be known among your friends that you'd like to borrow the mother cat and her litter. You'll find that kittens are easier to photograph than grown cats.

Puppies—they're another story. Try a bunch of lively, active puppies to really tax the skill and patience of both you and your assistant. You can get puppies from your friends, your local pet shop, or from breeders in your area. Once it is known that you're interested in photographing animals, you'll get calls from people telling you what they have.

To compensate the owners of the animals, you can give them a token payment and/or pictures of their pet. And don't forget to get the owner to sign a model release. This can be worded very simply, merely indicating that you photographed their animals with their permission and that some sort of payment was made.

A model release is hardly ever necessary, but sometimes some picture users —mostly advertisers—will require one before they will accept a stock picture. For

Both kittens and puppies are plentiful in the spring. Once it is known that you are interested in photographing animals, people will call you. A litter of kittens will require an assistant to keep them in the picture area.

custom shooting, it is routine procedure to obtain a model release.

My model release is worded as follows:

> For valuable consideration received, I, being of lawful age, consent that Walter Chandoha, photographer, or any persons or firms with the consent of said Walter Chandoha, may use photographs taken by him of my animal for all editorial, illustration, and advertising purposes.
> Signed: _____
> Address: _____
> Date: _____
> Witness: _____

You can purchase model release forms from some of the photo magazine publishers, or type up your own.

After you've photographed the animals in your neighborhood and from nearby kennels, you may want to get out to other potential model sources—shows, exhibitions, and fairs. Dog shows and cat shows are held throughout the year in all parts of the country. During the warmer months of the year and in the South the year round, dog shows take place outdoors. Huge tents, vendors of many and varied dog products, food stands (for dogs and people), thousands of cars, thousands of people, and thousands of dogs all contribute to give the outdoor dog shows a festive, carnival air.

Here you'll find almost all the breeds of dogs—some 118 of them recognized by the American Kennel Club. If you see a dog you'd like to photograph, approach the person on the other end of the leash and ask if you can make some pictures. If the person with the dog is the owner, you'll usually get 100 percent cooperation; from a professional handler, almost 100 percent non-cooperation. A professional handler at a dog show is an extremely busy person. He (or she) is hired by an owner to show a dog, and in a single day he may have to care for and show a dozen or so dogs. He simply cannot take the time for pictures at a show.

Both cat shows and dog shows are potential sources for models. Most owners of show animals will be happy to cooperate with you, well before or after the judging. Shows are a good place to set up shots like this.

The individual who shows his own dog, however, is at the show with one or two dogs of the same breed. He usually has lots of time before and after a judging. Because they have more time, owner-handlers tend to be more cooperative for picture-taking at dog shows. An offer of free pictures usually gets more cooperation.

During the cooler months most dog shows are held indoors (cat shows are indoor shows all year round). At indoor events you'll be using flash; but if you have a good eye for observing the play of natural light, try some fast film with the existing light.

Horse shows and agricultural fairs will give you lots of large animal models. If you're unfamiliar with horse shows and fairs, study the catalog or program that you purchase at the entrance gate. This will give you a good idea of the events of the day; some of them even have maps showing where various things are. Fairs last from three to ten days, and on each day different events are scheduled. You can get the schedule of events in advance by writing to the fair or by watching the local newspapers. Make a note of the day and time that the events that interest you occur, and go to the fair on those days if you don't have the time to attend every day.

Among the events I especially like at fairs are the horse-pulling contests. If it were not for these contests, we would see very few draft horses in this country. Watching these big, beautiful beasts put their all into pulling is always a thrilling sight, and the resulting pictures are fully as dramatic.

In addition to horses, you'll find the full range of conventional farm animals at agricultural fairs: cows, sheep, goats, poultry, swine, and so on. At all these events—horse, dog, and cat shows, agricultural fairs—keep in mind that you are photographing animals. The emphasis should be on them; backgrounds should be minimized. This is sometimes difficult. In the background—and sometimes in the foreground, too—there will be fences, tents, people, cars, feet, elbows, coffee cups, poles, trees, bare bright bulbs, cages—just about everything that makes for a distracting element in a picture.

Digression about backgrounds. When you encounter what I call a lot of "garbage" in the background, you're going to have to think like a professional photographer. In shooting on location or anywhere, for that matter, I do a thing called *cleaning up the viewfinder*. This is probably the one most important technique you can learn that will give your pictures the mark of a professional.

Here's what you do: While looking through the viewfinder at your subject, allow your eye to roam over the entire viewfinder in front of, alongside, above, and behind the thing you're photographing—animal or anything else. Do this immediately upon lifting the camera to your eye. If you find no distracting elements, fine! Most of the time, however, you'll find little insignificant things that are just enough to mar what would otherwise be a good picture. Maybe a tree in the background is apparently growing out of a horse's head. Move your position a few feet to the left or right, and the offending tree is better placed and you get a better picture.

Or, at a dog show, you have an appealing poodle sharply focused in the viewfinder and you notice the leg of a chair on one side just behind the dog and a crumpled coffee cup by his paw. Put the cup in your pocket, move the chair (or your position), and you've got a clean uncluttered background.

Or perhaps a cat is stalking through a jungle of grass, and as you're about to shoot you notice that a stray blade of grass is in front of one of his eyes. Now you have a problem. Do you reach out to remove the blade of grass to "clean up the viewfinder" and thereby lose a good shot, or do you shoot it as is? When faced with such a situation, shoot it as is and shoot fast. You may have a distraction in the picture, the focus may not be right on the nose, the exposure may not be absolutely accurate, and perhaps the composition could be improved, but shoot it anyway if the picture is what you consider fleeting. If you hesitate, the great picture you saw may be gone forever.

Now let's say you've gotten your quick-grab shot and the subject allows you to make additional shots. This is the time to focus more accurately, verify proper exposure, and compose better. With these technicalities in order, make another shot.

If your subject still offers to hold the pose, now is the time to clean up the viewfinder. Actually, all this fussing around took only a second or two between the first quick-grab shot and the final cleaned-up shot. So, when you see a good fleeting picture, shoot fast. If the picture lingers, improve upon it.

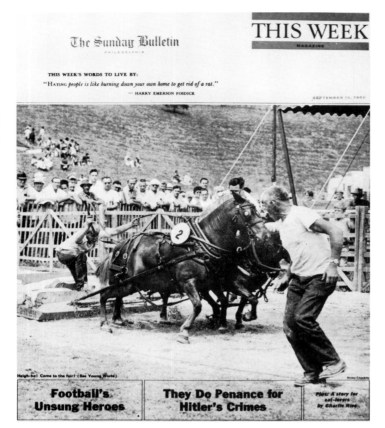

The Sunday Bulletin
PHILADELPHIA

THIS WEEK
MAGAZINE

THIS WEEK'S WORDS TO LIVE BY:
"Hating *people is like burning down your own home to get rid of a rat.*"
— HARRY EMERSON FOSDICK

SEPTEMBER 13, 1955

Heigh-ho! Come to the fair! (See Young World)

Football's Unsung Heroes

They Do Penance for Hitler's Crimes

Plus: A story for cat-lovers by Charlie Rice

Horse shows and agricultural fairs offer many picture-making possibilities. I especially like the horse pulling contests. For most dramatic results get right down into the ring, as close as you can. *As published in* This Week *magazine.*

The backgrounds at fairs and shows are usually full of eye-distracting elements—people, fences, tents, cages, and the like. By cleaning up the viewfinder, you can get rid of eye-catching "garbage." Simply by getting low and off to the side, a more effective picture was made of the pair of oxen.

Even though you should strive for perfection in every shot you take, sometimes—when the action or a pose is just right—it's better to go ahead and shoot even if there will be some flaws in the picture, such as the grass in front of the kitten's face here.

This technique of cleaning up the viewfinder should be used in all your photography—personals, travel, nature, landscapes. It takes only a couple of seconds and will give your pictures the mark of a professional. They will begin to look like those you see in books and magazines.

A short drive out into a rural area will bring you to farm animal country. Dairy and beef cattle farms are not far outside most large cities. Goats, sheep, pigs, and poultry can easily be located by inquiring at the office of your local county agricultural agent. Children raising animals for 4-H projects are also delighted to have you photograph their pets.

Farm animals are plentiful in rural areas, just a short drive from even large cities. Most farmers will let you photograph their livestock and poultry, especially if you make a few pictures of the farm family gratis.

ZOOS, GAME PARKS, AND THE TELEPHOTO LENS 12

AN AFRICAN SAFARI to photograph animals in their natural habitat is beyond the reach of most readers of this book, and so we'll deal with the next best thing— game parks. At these parks every effort has been made to simulate the natural environment of the animals. Located mostly in warmer parts of the country— Florida, Texas, and California—these "Jungle Lands" or "Safari Parks" enable you to make pictures that will be *almost* like those you'd make in Africa. The animals roam free—fences are invisible or unobtrusive. With patience and proper framing, you'll get some in-the-wild pictures that come close to the real thing.

Zoos, in recent years, have been getting away from the animal prison concept; i.e., putting animals in cages, behind bars. With the jail-type zoo enclosure you can't do much more than make pictures of an animal in jail. But if you're faced with such a situation and you don't want the bars to show, you have two choices. The best way, if you can get the cooperation of the keeper (and you should always work with the keepers at zoos rather than without them), is to poke your lens between the bars and shoot. *This can be dangerous!* Use this method only with the keeper's cooperation and assistance; he won't let you get into a situation where you might lose a head—and well you might if you try the between-the-bars bit without the permission and full cooperation of the keeper.

The other way to avoid the bars is to wait until the animal is a good distance back from them. Then get up fairly close to the cage, focus on the animal, and use a wide aperture. The bars will be so much *out of focus* that they will be rendered almost invisible.

With today's special 14- to 21-day air excursions to Africa, a photographing safari is now within reach of many people. Animals in African game parks have become so accustomed to people in cars that it is possible to get tight close-ups even with modest telephoto equipment.

Fortunately, bars and cages are not too much of a problem at zoos any more. As funds become available to the older zoos, they are converting the jail-type enclosures to barless, natural environment exhibits. I've made pictures in the Bronx Zoo in New York and the zoos in Chicago, Philadelphia, St. Louis, and San Diego, and many of their exhibits are barless and provide an unobstructed view of the animals.

In small animal photography where you can get close to your model, you need supplementary close-up lenses to get large, sharp images. In big animal photography—especially at zoos and game parks—the problem is the distance between you and your subject. With a normal lens you get sharp images but they are small. You have to use telephoto lenses to get sharp, big images.

The focal length of the telephoto will determine the size of the image: the longer the focal length, the bigger the image. A normal 50mm lens on a 35mm camera at a given distance will produce a hypothetical image ¼ inch high; a 105mm lens will double that image to a little more than ½ inch. A 200mm telephoto will make the image 1 inch high, or about the full height of the horizontal of 35mm film.

▶

More and more zoos are making their exhibits into natural environment habitats without bars. These are big improvements over the jail-type barred enclosures of the past—better for the animals and better for photographers. This picture was made in the African Plains exhibit at New York's Bronx Zoo.

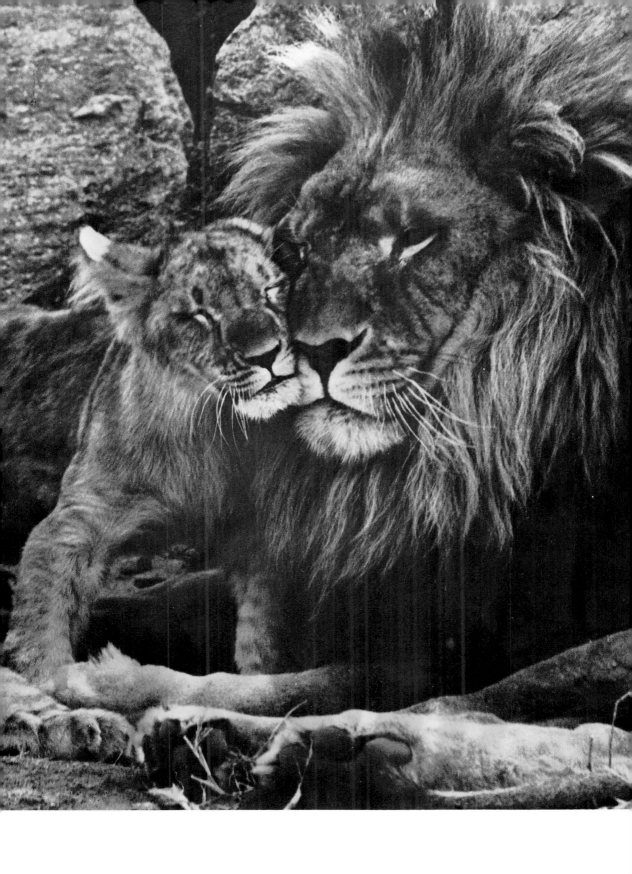

For sharp, large close-ups at zoos and game parks, telephoto lenses are required. Generally, the longer the focal length of the telephoto, the bigger the image.

If you plan to do much zoo or wild animal photography, a telephoto lens is essential to get large images on your negatives or transparencies. A 135mm or 200mm is a good single choice for zoo photography. This focal length is long enough to bridge the gap of 20 to 40 feet between the animals and the barrier where you'll be standing.

At some exhibits 85mm or 105mm short telephotos, which are used more for portraiture, will be adequate and will give you fairly large images. If you're shooting in black and white, you can always enlarge a portion of a negative to get a bigger image on your print. But with slides you're usually locked into the size as you shot it.

Long, long telephotos like the 300mm and 500mm are too long for many zoo situations but are ideal for game park shooting. There are also zoom lenses that are the ideal to use for most zoo photography. They are especially good when your subject is constantly moving near and far away from the camera.

Consider a scene with a mare and a lively, romping colt. One minute the action is right under your nose, and in the next few seconds away they gallop to the far end of the field. With a zoom lens on your camera, all you do is go to maximum telephoto to catch the far action; when they come galloping to a near position, zoom back to a shorter focal length. It can all happen as fast as you read these words.

If, instead of using a zoom lens, you had to switch from an 85mm lens to a 200mm telephoto and then back to the 85mm as the action moved from close to far and back to close again, you would miss a lot of good pictures. For some reason or other, the good pictures always seem to occur when you're changing lenses. You can also solve the problem of the near and far action by using two

Where your subject is constantly moving—as with a romping colt—a zoom lens is superior to a single focal length telephoto. When the subject moves closer, you shorten the focal length. When it moves further away, you zoom out to increase the focal length.

cameras—one with a normal or short telephoto and the other with a long telephoto. With a zoom lens, however, your framing will be better.

For those of you who are not familiar with the zoom lens, here is how it works. Its focal length can change from a fixed minimum—say 80mm—and zoom out to a fixed maximum—say 200mm—with any desired intermediate focal length available between the minimum and maximum. With most lenses the point on which you've focused will remain sharp at each changed focal length.

The older zoom lenses have two adjusting rings—one to change the focus and one to change the focal length. This is sometimes difficult unless you have three hands—one to hold the camera, one to change the focus, and the third to change the focal length. The newest generation of zoom lenses have combined the zooming and focusing ring into a single unit. Now you focus by twisting the ring to the left or right as with conventional lenses, and you zoom or change focal length by "tromboning" the same focusing ring in or out. It's a great convenience for us photographers who don't have three hands! It's even easier to use when the camera is mounted on a tripod.

Some of the older zoom lenses had another glaring fault—they were not quite as sharp as a lens of a fixed focal length; i.e., a 200mm telephoto would produce a sharper image than an 80 to 250mm zoom lens when the latter was set at 200mm. The current crop of zoom lenses have changed all this. Zoom lenses are now sharp! The sharpness of the pictures made with a *top quality* zoom lens is indistinguishable from those made with fixed focal-length lenses.

Notice that I said *top quality* zoom lenses. Like good cigars and good bourbon, a good lens is expensive. If you want top quality you have to pay a high price for it—you get what you pay for. Suppose that of two lenses of equal focal

length, one sells for $100 and the other for $350; both are brand-new current models. Isn't it logical to assume that there must be a difference in the workmanship, which in turn will make a difference in the quality of the pictures produced? If you want to get top-quality photographs, buy good quality lenses. Stay away from so-called bargains. This is especially true with telephotos and zoom lenses.

Whether you use a zoom lens or a conventional telephoto, you'll get nice big images on your film. And if you're not careful how you use these lenses, you'll get nice big blurs, too. The longer the focal length, the greater the chance of blur due to camera movement.

You can minimize or completely eliminate camera movement if you remember this rule: For hand-held shooting, don't use a shutter speed any slower than the focal length of the lens. The normal lens on a 35mm camera is 50 to 55mm. When using this lens, set the shutter at 1/60 sec. For a 200mm telephoto, use a shutter speed of at least 1/250 sec. This is a rule to use when conditions are ideal.

But there will be times when the light is such that you won't be able to use a fast shutter. The lens will be wide open, and to get the proper exposure you'll have to shoot at maybe 1/30 sec. or even 1/15 sec. Now just because you read here that you shouldn't use a shutter speed slower than the focal length of your lens, it doesn't follow that you shouldn't make an exposure if a good picture opportunity is there.

By squeezing the shutter gently and slowly you'll minimize camera movement. But the best way to minimize camera movement—at either slow or fast shutter speeds—is to use a tripod. For getting sharper pictures of *anything,* remember this rule: Whenever you can, use a tripod. Even those inferior lenses you shouldn't buy will give you their maximum sharpness when in use with a camera mounted on a tripod. And if you can't take the time to use a tripod with its legs full spread in the conventional manner, then use it with the legs closed— like a unipod.

If you'd rather not be encumbered with a tripod, then by all means invest in a unipod. This is equivalent to one leg of a tripod—it adjusts up and down and is usually topped with a ball and socket head on which the camera is mounted. You'll be pleasantly surprised at how much sharper your pictures will be when made from atop a unipod—but they'll be even sharper when made from a tripod.

Another rule: If a picture is worth doing, it's worth doing well. Why not use a tripod? Lazy? Lethargic? Too weak to carry one? If you can get good sharp pictures by using a tripod, why not use it? Even if you're making panned blurred pictures, you will have better control when you pan from atop a tripod.

You still prefer to wing it and not use either a tripod or a unipod? O.K., then use your head—literally. By resting your camera strategically on some part of your head or face (but not balanced on the tip of your nose), it will be steadier and your pictures will be sharper. Or try turning your single-lens reflex camera upside down and resting it against your forehead.

With 2¼ cameras, steady them on your knee, on the ground, or against any

A good rule to remember when shooting without a tripod is to use a shutter speed no slower than the focal length of the lens. A 200mm telephoto uses 1/250 sec.; a 105mm requires 1/125

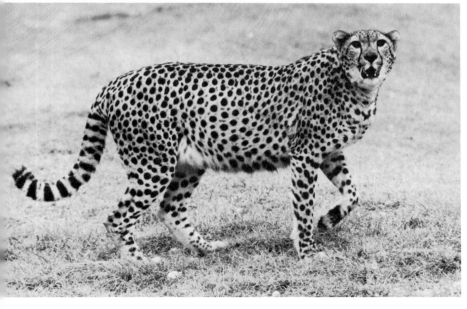

You increase your chance of getting sharp pictures when your camera is on a tripod. You can frame your subject better, and you eliminate the possibility of getting a blurred picture because of camera movement.

solid surface. With all cameras make use of your surroundings to give support—a wall, a log, a fencepost, or a chair. Use the camera neck strap to increase steadiness by taking up slack or pulling against the strap, and with your legs spread wide apart you make your body into a bipod.

Still another way to get around the slow shutter speed is to use a faster film. Kodachrome II film is ASA 25; say you have a dull day and your meter calls for f/4 at 1/30 sec. By using ASA 160 High-Speed Ektachrome film, in the same light you can shoot at f/4 at 1/125 or 1/250.

Another device that many professionals use to avoid camera movement when releasing the shutter is the self-timer. This device is used mostly to enable a photographer to include himself in a picture. With the camera on a tripod or other steady surface, the self-timer lever is activated; then, when the subject is in the proper pose and sharply focused, the shutter is released. In about ten seconds—enough time for any camera vibrations to cease—the shutter will go off. If your subject is relatively immobile and is not moving in and out of focus, you'll get a good sharp image. Obviously, with fast-moving action you'll not be able to use this trick.

At zoos and game parks you're going to have to play the waiting game—even more so than with photographing pets like cats and dogs. With small animals in a controlled situation such as a studio, you can encourage action with food and sounds. Most zoos discourage—even prohibit—the feeding of animals, so you're going to have to wait until the animals get into a picture-worthy situation. This may occur the moment you arrive or not until you've been watching and waiting for many hours.

The feeding schedules at zoos are usually posted at each exhibit, or they can

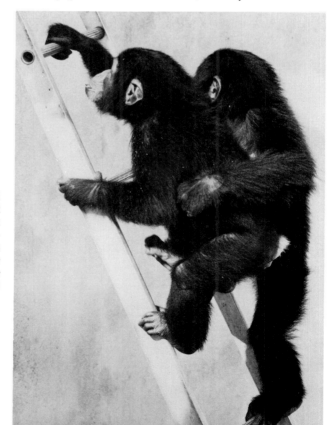

Because you have absolutely no control over either the animals or the light at zoos or out in the field, you'll spend a lot of time waiting for something interesting to happen. These chimps were sitting picking each other's hair for about a half-hour. When they finally quit and decided to climb the ladder, I got an interesting shot.

You'll have to take the light largely as you find it when shooting outdoors on safari, in game parks, aquariums, and zoos. The only "control" you'll have is to revisit a given exhibit at a different hour of the day when the sun is in a different position. Backlighting is sometimes very effective.

be determined by inquiring at the administration building. Creatures of habit, zoo animals look forward to feeding time with much anticipation. Think about it. What else have they got to look forward to? Their sex life is either thwarted or limited, and so food is the big event in their day.

Feeding time is at the same hour every day for a given animal. The time varies from animal to animal, but feeding goes on throughout the day, throughout the zoo. You can adjust your zoo itinerary to make sure you're at an exhibit when the animals are being fed. Why at feeding time? They may be sluggish or lethargic at other times of the day, but they become alert and full of anticipation just before being fed. And when they get their food, their eating habits sometimes result in good pictures.

For serious picture-taking at zoos, try to avoid "no school" days, weekends, and holidays. Zoos tend to be crowded then. Some zoos may even prohibit the use of tripods on peak crowd days. And even if you're shooting hand-held, crowds closing in around you will nudge and push, resulting in some unintentional camera movement. Most important, despite the prohibition on feeding, many people will still feed the animals. More than once I've had a shot all framed in anticipation of a certain action, when someone came along and threw some food into the pen. Naturally the animal went for it and my shot was lost.

So if you have a choice, go to a public zoo or game park during non-peak

periods or, if you can only go on weekends, be there when the gates open. You'll have at least two hours of good shooting before the crowds come in. And you'll have better light early in the day.

Lighting can be a problem when shooting out in the field, at game parks or zoos. Since you'll not have the option of changing your position relative to your subject, or of changing the position of your subject, you'll have to take your pictures with the light as you find it. It will never be so bad that you can't take pictures, but sometimes backlighted situations will be tricky if you're not careful about shading your lens. Use a lens shade or, better, if your camera is on a tripod, use your hand to cast a shadow over the lens.

If the light at an exhibit is not what you'd like, go back to the area at another hour—later in the day or earlier. If the light is too spotty—say the exhibit gets sunlight only at midday, when the sun is high overhead and casts harsh shadows, or if nearby trees produce a spotty sunlight and shade situation—try shooting the same exhibit on a bright overcast day, or wait until the entire exhibit area is shaded. You'll get a soft, even light then, which will give you better pictures.

If you're unfamiliar with a zoo, purchase a guidebook first thing. Most guidebooks are profusely illustrated and provide a lot of background information on the animals. They generally also contain a map of the zoo showing the location of each exhibit. If you note the position of the sun in the sky and the locations of the exhibits you're interested in, relative to the sun, you can plan your itinerary to take advantage of the best lighting at each area at a given time of the day.

Make notes in your guidebook or in your notebook: when you were there, the date and time, and the position of the sun. Note also the feeding times and the reactions of the animals before and after they received their food. Jot down the name of the keeper if you know it (and why don't you?).

Ask the keeper if any baby animals are about to be born or to be exhibited, and make a note of the dates. The young of any species always lend an added dimension to an animal picture.

After you've made some pictures at an exhibit, take a picture of the nameplate identifying the animal. This will give you positive identification of the animal and some information about his background or native habitat. But make sure the nameplate and the animal you photographed are one and the same. Sometimes animals are put into an enclosure temporarily. The keeper or the guidebook will tell you what's what.

Aquariums, marinelands, and water exhibits at zoos should also be considered extensions of your "studio." Fish and swimming mammals are obvious subjects. Sea lions and whales are trained to perform at specified hours at some exhibits. And as with other zoo animals, sea lions are especially active at feeding time.

Fish in aquariums should never—*never*—be photographed with flash on the camera pointing into the glass tank. The glass will reflect the flash back into the lens and you'll get a big white flare on your film instead of a fish.

The best way to shoot fish in aquarium tanks is with the existing light—

If you don't see baby animals around, ask the keeper if any have recently been born or are expected. The antics of the young of any species are invariably more amusing than the quiet dignity of mature animals.

Feeding time at aquariums and zoos is an especially good time for pictures. "Dinnertime" is posted at each exhibit. Whales and sea lions can be photographed leaping up to catch fish tossed to them by their keeper.

preferably with the camera on a tripod. Because the level of light in some tanks will be minimal, you'll need the fastest color film you can find. Most fast black-and-white films are capable of producing good exposures in all but the darkest fish exhibits. Use a light meter—if it indicates that there is an adequate amount of light for the film you're using, you have no problems. If the level of light is low and if the fish you want to photograph are slow-movers, you *might* be able to use a slow shutter speed—with the camera on a tripod.

Keep your camera as close as possible to the glass of the tank you're photographing. This will minimize reflections. A polarizing filter will also *reduce* the degree of the reflection.

If you don't have enough light to shoot indoors, you'll still have many subjects to photograph outdoors. The big "fish"—whales, sea lions, and seals—are usually outdoors. Penguins have an exhibit area all to themselves, and are very photogenic.

Very often overlooked at zoos and parks are the ponds and lakes with their many varieties of birds. Ducks, geese, flamingos, cranes, and swans are some of the more common varieties found in these aquatic exhibits. Since zoo and park birds are accustomed to people, no great problems are encountered. A telephoto lens is the only special requirement. And, as with all animal photography, the patience to wait for an interesting expression, pose, or composition.

Photography of small birds—native birds—is an area of picture-taking I have never gone into, mostly because I have been too engrossed in animal photography. With just twenty-four hours in a day, we have to eliminate that which we deem least important—or more complex. Actually, bird photography is a specialty in itself. There are four basic methods of getting bird pictures:

The first is much like field photography of animals. Use the largest telephoto lens you can, put your camera on a tripod, and shoot the birds as you find them.

The next is to use the telephoto lens in a blind. Hopefully, after a while the birds will take the presence of the blind for granted (with you and the camera in it), and they'll come close enough for you to get your pictures.

The third method is a variant of the blind method—install a feeder outside your house, adjacent to a convenient window. Make sure it's close enough so that you can get a good-size image with the equipment you own. This is the easy way. Fill the feeder, set up your camera focus, and wait.

The last method is the most complex and the most expensive. It requires speed lights and a remote shutter release or "magic eye" shutter release, and a motorized camera. Briefly, it works this way. You set up strobe lights where you know the birds will be—say, a nest—set up your camera, determine the proper exposure for the lights, and focus on the picture area. Run a shutter release from the camera to a blind. When the birds come to the nest and are in the proper focus, you shoot. The flash and shutter go off, and you have your shot. If you have a motorized camera, the film is advanced, the shutter is recocked, and you're ready for the next shot. If you have an ordinary camera, you have to leave the blind, go to the camera, and advance the film manually.

Going a step further, the same setup is used with a "magic eye" release. But instead of shooting the picture yourself from the blind, the bird shoots its own picture by breaking an invisible beam of light that passes between two positions that you previously set up close to the nest. This is the same type of "magic eye" that opens doors for you at airports and department stores.

For those of you who want to go into bird photography in depth, I would suggest buying a book that deals with that subject exclusively.

13 CIRCUSES AND RODEOS

HORSES AND ELEPHANTS are a big part of every circus. A wild animal act with lions or tigers is a standard fixture in most of the larger circuses. Add a few performing bears, some chimps, zebras, seals, and camels and you have a lot of potential models for animal photography.

The big Ringling Bros., Barnum & Bailey Circus no longer performs under canvas as it did years ago. Too bad! There is something about a tent circus that is more interesting than one in big city arenas. Tent show or not, the Ringling Bros. Circus still offers the greatest potential for animal photographers.

A ringside seat and a telephoto lens will get you some fairly good shots of the action going on in the ring in front of you. The light level in most arenas is so high that you'll have no difficulty in shooting either color or black and white with existing light. Don't bother with flash—you'll be too far away from your subjects for it to be effective.

Your circus pictures will be better exposed when you shoot while the subject is bathed in white light rather than colored light. Colored lights reduce the intensity. As mentioned earlier, the very best results will be obtained when both the house lights are on and the act you're photographing is spotlighted. Some but not all acts are lighted this way. With a black-and-white ASA 400 film like Tri-X, you'll get good shots of most of the circus acts with an exposure of f/4 at 1/250 sec.

You can use this same exposure with Kodak High-Speed Ektachrome film if you rate it at ASA 400 and instruct your processing lab to develop it for this

Some circuses no longer play under tents, but if you can find one that does, there are lots of picture opportunities during the early morning setting-up period. You'll find the liberty horses tethered, and elephants being used to help set up the tents.

The light level in most circus arenas is so high that there is no difficulty in shooting either color or black and white with the existing light. With the big cat acts in cages, wait for a dramatic moment such as this—all the cats sitting on their hind legs.

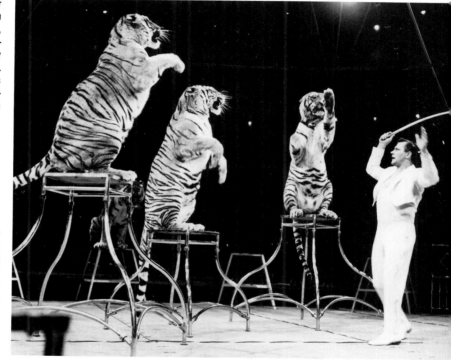

speed. Or buy the special processing mailers from Eastman Kodak Company for this increased speed.

When using color film at the circus, use indoor film—Type B, the film that is made for use with tungsten light. You can use daylight-type film for tungsten light pictures, but your transparencies will be overly warm. They will look too red or too yellow. On some subjects the increased warmth won't be too objectionable—in some cases it might even produce a desired effect—but overall you'll be better pleased with the results if you use Type B film with tungsten light.

Shooting from a ringside seat will tend to limit your picture possibilities even with telephoto equipment. You have an alternative: Go into the ring with

the press photographers. You can get there in three ways. The first way is to go to the publicity chief of the arena where the circus is performing and ask for press credentials, which will give you permission to shoot from the sidelines. The very worst they can do is say no; but if you're a convincing and sincere individual, they might say yes.

The next course open to you is to go to your local newspaper and ask them for credentials. Their staff photographers will go to one or two performances and that will be the extent of their attendance. Since circuses can thrive and flourish only if they get publicity, they are lavish with credentials for the local press. So there is a strong likelihood that you'll be able to get a circus pass from your local newspaper. If you give them first choice of the pictures you shoot, you might even sell the paper a picture or two.

The third possibility is to pay a regular admission, enter the arena early, and brazenly bluff your way into ringside, taking your place with the other photographers. Act as if you belong there, and no one will bother you.

When you're down in the tanbark you'll have to be alert. There are certain courtesies that press photographers usually observe and amateur photographers invariably ignore. *Stay out of the way.* Stay out of the way of the working photographers and stay out of the way of the circus personnel, both the roustabouts and the performers.

Don't litter. Why is it that an amateur who has all the time in the world will soil his picture area with spent flash cubes, empty film boxes and wrappers, and Polaroid papers? Yet the press photographer who is under more strain and stress will dispose of his photo garbage properly. When you're at the circus—or anywhere taking pictures—be clean. Carry your photographic trash home with you.

The big Ringling Bros. Circus is by no means the only show around. There are still many good regional circuses that play under tents and are full of the nostalgia of the old circus days. These circuses travel from town to town by truck, play for a day or two, and then move on to another place.

If one of these tent circuses plays near your town—you'll know the date; posters are prominently displayed around town several weeks beforehand—get to the site early in the morning. You'll get good shots of the elephants at work helping to set up the tents. Liberty horses will be tethered alongside their trucks. Keepers will be feeding and airing the menagerie animals.

This early-morning setting-up period is usually housekeeping time for the circus stars. It's also a time for relaxing. If you see an animal in a cage or tied to a wagon and there are people nearby, it's a good bet that the animal and the people belong together. As tactfully and as diplomatically as you can, ask the owner if you can take some pictures. You'll usually get cooperation. Try to talk them into taking the animal to an area beyond the tents, trailers, and trucks where you can shoot without a lot of clutter in the background. Don't forget about "cleaning up the viewfinder."

Small circuses are generally easier to work from ringside than the big ones. Since the small "big tops" usually play smaller towns, there is more informality

In certain instances, flash can be useful at the circus—such as freezing the peak action of a leaping equestrian. If this picture had been made with available light, both the horse and girl would probably have been too blurred to be effective.

By proper timing you can stop peak action with even slow shutter speeds when shooting with available light. If you can, take time to sit through one performance of the show just to see what is happening and to make notes of potential picture subjects. Then, during the "shooting" performance, you will come up with some pretty good pictures.

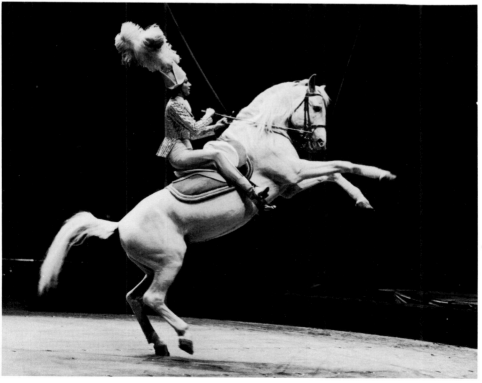

Elephants are a fixture in every circus. Get to the circus grounds early and you'll find some ready to pose for you—if you can talk their keeper into cooperating with you.

between the circus management and members of the press. You'll be treated like a professional if you behave like a professional. Remember—stay out of the way and don't litter!

RODEOS

Except for a few of the big ones held in indoor arenas—usually the same arenas where the circuses played—most rodeos are outdoor events. Since most rodeo events feature fast action, shutter speeds of 1/500 sec. and faster will be required. Even with this shutter speed you'll have no trouble getting good exposures in bright sunlight with slow-speed films like Kodachrome II. But because the action will be all over the place, you might be better off using a high-speed color film to take advantage of the increased depth of focus of smaller f/stops.

A good technique for shooting rodeo events (or other fast-moving action) is to use zone focusing. In zone focusing you make use of that great picture-sharpening optical phenomenon called depth of field. This is the area in a picture that is rendered sharp in front of and behind the exact point of focus. This area of sharpness—or depth of field—increases as a lens is stopped down; i.e., your sharpness is greater at f/16 than it is at f/8, and it's greater at f/8 than it is at f/4, and so on. The area of sharpness is usually greater behind the point of focus than in front of it, in about a 1/3 to 2/3 ratio. In other words, about 1/3 of the area of sharpness is in front of the point of focus and about 2/3 is behind it.

Aside to nit-picking critics and technicians: Neophyte photographers tend to use the terms *depth of focus* and *depth of field* interchangeably, so rather than confuse the issue I prefer to treat them as one and the same thing, as described above. I am also aware that lenses achieve their optimum sharpness 2 or 3 stops down from their maximum aperture. The sharpness most people are concerned with is generally overall sharpness rather than critical maximum sharpness. So for a general overall sharpness I recommend using the smallest aperture possible for the shutter speed that will stop the action at hand.

Most rodeo events are fast action, and so shutter speeds of 1/500 sec. or faster are required. Because the action moves all over the place, estimate the approximate area where the riders will be, set your focus for that distance, and forget it. Depth of field will compensate for errors of several feet.

Getting back to depth of field. Somewhere on your camera, or on the lens or on a chart supplied by the manufacturer of the lens, you'll have an indication of the depth of field for each aperture. Interchangeable lenses for 35mm and 2¼ cameras have the depth of field scale engraved on the lens barrel. Cameras like the Rolleiflex have the depth-of-field scale around the focusing knob. Lenses for view cameras have charts indicating the depth of field. A good textbook on photography usually contains depth-of-field charts for lenses of all focal lengths.

In zone focusing, rather than trying to focus on fast-breaking action as it

Even with fast shutter speeds, today's fast films will enable you to get good exposures in both black and white and color. Try to anticipate the action and shoot at its peak.

moves back and forth, estimate the distance (front and rear) where the action will occur. Then consult your depth-of-field scale. Set the focus on your lens to a point 1/3 beyond the point of closest sharpness. You can be assured that if the action falls anywhere within the area indicated by the depth-of-field scale, you'll get a sharp picture, assuming that you don't move your camera during exposure.

Unsharp pictures are due to faulty focusing, camera movement at the instant of exposure, or using a shutter speed too slow to stop the action. A poor lens or a film not lying flat in the camera are also causes of unsharpness, but since you can rarely control these problems we'll not deal with them here.

If you steady your camera when you shoot and sq-u-e-e-z-e off each shot, you will have eliminated one of the major reasons for unsharp pictures—camera movement. Use a tripod for added sharpness insurance. If you use a shutter speed of 1/500 you'll stop even the fastest rodeo action. And, finally, if you focus carefully or use zone focusing, you'll get sharp pictures.

Keep in mind the approximate 1/3 and 2/3 division of sharpness in front of and behind the point of focus. If you calculate areas of sharpness, it is better to have more sharpness in the foreground than in the background. If the nose and eyes of a horse are sharp and his rump is out of focus, you have a picture. If the focus is reversed, you have a reject. Therefore, if you must err, it is better to have the background slightly out of focus than an important piece of action in the foreground.

Because rodeo action is so fast and so unpredictable, the ring is not the best place to shoot from unless you know your way around fast-moving horses and steers—or are using long telephoto lenses.

A good vantage point is up in the judges' or announcer's stand, if it's not

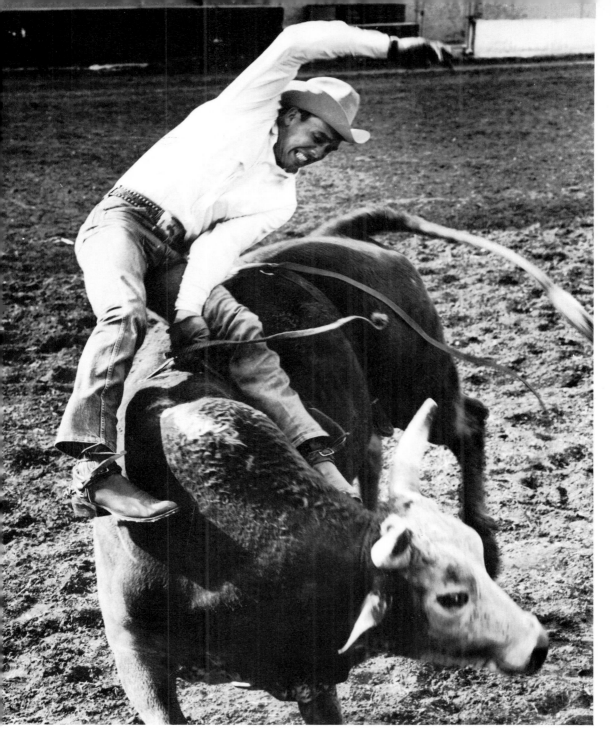

Unless you know your way around fast-moving broncos and steers, you'd best avoid being right down in the ring. A good camera position is on the fence just to one side of the chutes. This elevated position will eliminate a lot of the busy background that is always in evidence at rodeos.

located way up atop the grandstand. For "sand-lot" rodeos, find a solid section of fence and shoot from it. The elevation of about 5 to 8 feet will eliminate a lot of busy background.

There will be times when, no matter where you shoot from, you'll have no choice but to include people, fences, and grandstands in the background. When this happens you just have to shoot it like it is. However, if you frame tight—i.e., fill your viewfinder with more subject than background—you eliminate a lot of clutter. In any event, a certain amount of background of people and grandstands is not too objectionable—it establishes the setting.

Sometimes you'll have no choice but to include extraneous background in the picture. When this occurs, crop as tightly as possible in the viewfinder and then crop even more in the darkroom.

SELLING
WHAT YOU SHOOT

Now THAT YOU KNOW how to get good animal pictures, maybe you're thinking about turning pro. To the uninitiated the thought of being a free-lance professional photographer is comparable to paradise. The free-lancer has the ideal job —no boss, no time clocks, days off anytime, big fat fees, and no sweat. Sounds great. But is it?

The free-lance photographer has no boss—no single boss. He has many bosses! Everyone who asks him to make pictures is his boss. True, he can't be fired in the usual understanding of the word—but unless he can do a better than average job, he won't be hired either.

No time clocks? When you become a free-lancer, forget the eight-hour day and the five-day week. You'll spend all day shooting and all night processing. You'll work Saturdays, Sundays, and holidays. When you're not shooting or processing, you'll be out selling. A 12- to 18-hour day and a seven-day week will be the rule rather than the exception.

And as far as taking a day off any time you like, forget it. You won't even have time to get sick. Sick days and sick pay are no part of free-lancing! You'll get a day off only when there is a lull in the business and your accounts receivable are in a stronger position than your accounts payable.

Big fat fees? Forget them! When you start in this business, you'll literally start at the bottom as far as fees are concerned. Initially you'll be at the mercy of the buyer. He'll tell you what he can pay, and if you want the work you'll take

How's THIS for a baby sitter

A free-lance photographer has no boss, but he has to answer to everyone who uses his talents. Most important of all, he has to be constantly alert to potential sales. An outing at the beach on a "day off" paid dividends with the sale of this "babysitting" situation. *Used by special permission of Parade Publication, Inc.*

CALIFORNIA, Md.

When Photographer Walter Chandoha and his wife took their one-year-old daughter, Paula, to the beach here the other day, they also took along a baby sitter. While Mama and Papa went for a swim (a few yards away), Spook, their brindle Great Dane, stood guard over Paula. Spook took his job seriously, looked as ferocious as possible. Actually, he's gentle and affectionate—but nobody bothered Paula.

Happy Paula clutches one foot in delight.

➤ Shots like these—with sales appeal—can be achieved by using your own or the neighbors' children and their pets as models.

what he offers. Only after you've been around a while and have a reputation will you be able to command the big fat fees of free-lancing.

No sweat? There is a saying on Madison Avenue: "What have you done for me lately?" Memories are short. No matter how good a job you did on an assignment last month, if you've messed up last week's assignment there is a good possibility it will be your last. So you'll sweat over each and every job until you have the confidence that comes only with years of solid experience behind you.

There is a big difference between amateur and professional photography. An amateur has all the time in the world to make pictures of his own choice, and he has only himself to satisfy. The professional must produce good pictures consistently. They must please not only him but also the client. And a professional must be dependable—he has to deliver satisfactory photographs on or before a given deadline.

There is also a big difference between working at a job where you know you'll be paid a certain minimum sum regularly, and working as a free-lancer,

"What have you done for me lately?" is a cliché often heard on Madison Avenue. Even though ads like this win awards, the photographer must constantly produce new and exciting pictures to stay on top in the competitive field of advertising photography. *Used by special permission of Ohrbach's.*

where you will not know from one week to the next what your income will be —if any!

For many years there was panic in our house when we had "nothing coming in." Absolutely no accounts receivable and a fast-receding cash reserve. With a lot of mouths to feed and bills to pay, "nothing coming in" can be frightening. But if you have faith in your ability and the will to succeed, you'll just push a little harder until you turn the financial tide.

Faith, tenacity, and determination have to be part of your character if you want to be a successful free-lancer—you must *want* to succeed. And you have to love what you're doing. Your work should consume you. If you wonder—too often—why you're in such a risky and uncertain business, get out! Get a nine-to-five job. If you begrudge the long hours and the short pay, and if you must have fun-filled leisurely weekends—forget free-lancing. If you keep putting off until tomorrow what should have been done yesterday—forget free-lancing. A free-lance photographer has to be a self-starter: he has to drive himself; he is his own boss, and a boss is someone who makes things happen!

Do I paint a bleak picture of the lot of a free-lance professional photographer? Actually, it's not all that bad. At first it will be rough going, but after you've made it, you'll know the sweating and struggling were worth it. Free-lancing really has lots of things going for it. It's the ideal job—no boss, no time clocks, days off any time, big fat fees, no sweat! Aren't these reasons enough for anyone to want to be a free-lance photographer?

One of the best ways to direct attention to your move into the specialty of animal photography is to enter—and win—photo contests. These are sponsored by manufacturers, publications, and organizations for various purposes, mostly to sell products or to get publicity. Your objective in entering such contests is first and foremost to get publicity for yourself. If at the same time you win some prize money, so much the better.

Some contests are for amateurs only and some are open to both amateurs and professionals. When you're making the transition from a part-time weekend photographer to a full-time professional, you are still considered an amateur by most contest rules. These define a professional as one whose main source of income—at least 50 percent—comes from sources that are photographic. So if less than 50 percent of your total income comes from photography you're still an amateur, even though your knowledge of photography and your ability to take great pictures may be on the same level as that of many pros. If you've made the break and are a full-time professional you'll be able to enter contests open to professionals.

The first and most important thing to remember when entering contests is to *read the rules*. If the rules say color only, don't enter black and whites. If the limit is four pictures per entrant, don't send in ten. But by all means always send in the maximum number of prints permitted.

Read the rules and follow them to the letter. Especially note the closing date. The physical handling of a great number of contest entries is an enormous

Free-lancing is *not* a nine-to-five job. You'll spend long hours in the darkroom, many hours out selling, and the rest of the time shooting. You'll always be looking for picture situations that will result in sales. They can occur right in your home, as this sequence did, or you can find stories in the world around you. Give yourself self-assignments—don't wait for the telephone to ring. Unless you get out and hustle, it never will.

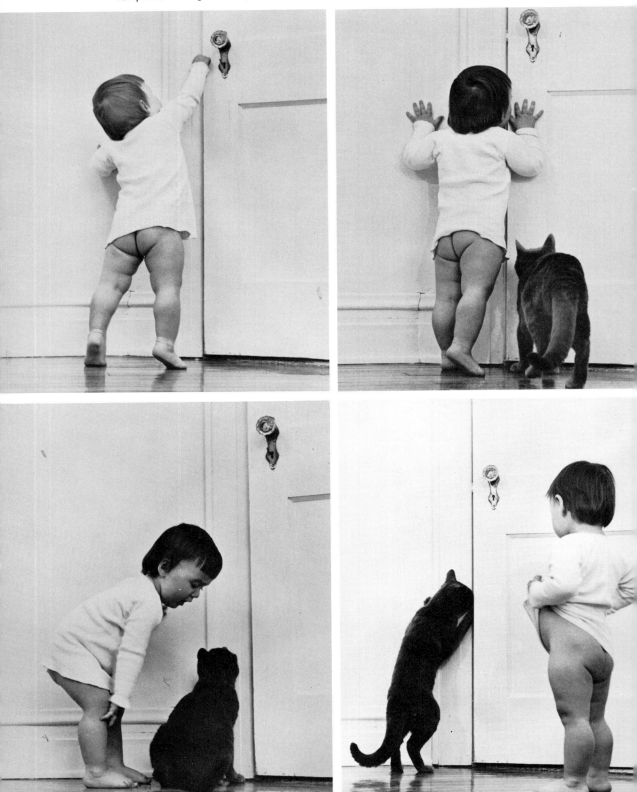

task; hence, a firm cut-off date must be observed so that the pictures can be readied for judging.

All entries are first screened, and it is at this first screening that the great majority of pictures are eliminated. Wrong subject matter and obviously poor photographs cause many pictures to be thrown out on the first go-round. Those that survive the preliminary screening go before the official judges for selection of the prize winners.

The judges then do their own eliminating, narrowing the choice down to several dozen of what *they* consider the best of the group. The personal preferences of each judge play a large part in what pictures are ultimately selected as winners. The theme or objective of the contest is reviewed before a final choice is made, to make sure the prize winners are on the right track.

For example, I sometimes judge a contest for the New York ASPCA. It is an animal picture contest with the theme "the relationship of animals to man." There have been several superb photographs of individual animals that survived the preliminary screening because of their excellence, but that were eventually eliminated by the judges because they did not follow the theme of the contest.

What finally is selected as the first prize winner is usually a consensus of the preferences of the panel of judges. When it gets down to picking the first, second, and third out of a group of outstanding pictures, a lot depends on how forceful a judge is in persuading his peers that the picture *he* prefers deserves a top prize. Chances are that the top five are all so good any one of them could be worthy of the first prize.

The fact that personal preference plays such a big part in the final selection of a winner is the one big reason why you should enter every contest you learn of. Who knows—you just might enter what some forceful judge finds irresistible. But first you have to enter. If you don't enter a contest, you can't possibly win!

Where and how should *you* start your new career? First of all, don't start as I did. I jumped in with no financial security. When I was in college, I was fortunate enough to sell a few of my first cat pictures to newspapers and magazines. On the basis of these early sales, plus winning a few cash prizes in photo contests, I decided to become a free-lance professional after graduation. I had chosen marketing as my major in college, primarily because I thought I might like to be an art director or a copy writer. Now, after many years of involvement with the intrigues and machinations of Madison Avenue, I can see in retrospect that remaining on the fringes of the advertising business was a wise choice for me. I have an idea that one of the reasons I never went into advertising was my mental image of the idyllic utopia that I thought was free-lancing. And this was even before the motion picture *Blow-Up*, which probably convinced thousands of neophyte photographers to turn pro.

Actually, I didn't ponder at any length whether to choose the advertising business or free-lance photography. Ever since I had become interested in photography back in high school, I had loved it. It was something I enjoyed doing then and I enjoy to this day, so there was really no great decision to make. I just wanted to be a professional free-lance photographer.

THE PICTURES THAT WON $25,000

POPULAR PHOTOGRAPHY

WORLD'S LEADING PHOTOGRAPHIC MAGAZINE

DECEMBER, 1955

50 CENTS

BIG 1955 CONTEST ISSUE

PHOTO GIFTS YOU CAN MAKE

DISNEY'S AMAZING CIRCARAMA

2nd prize-winner by Walter Chandoha

ELECTRICITY FOR THE PHOTOGRAPHER

One of the best ways to test your skill as a photographer—to learn if you're ready for free-lancing—is to enter photo contests. If you are a consistent winner, you just might be ready. The cash prize money will help you pay expenses, and the publicity you get will be a valuable stepping-stone toward your professional career. *Used by special permission of* Popular Photography.

As soon as I earned my degree I took the plunge, and it was sink or swim. I *had* to succeed. But it would have been so much easier for me if I had first worked for a magazine photographer, to learn about this facet of photography and to learn more about the *business* of photography.

At that point in my budding career, I was a fairly competent all-round photographer. Before college, I had been in the Army as a Signal Corps photographer during World War II, and before that I worked as an assistant to one of the best illustration photographers in New York—Leon DeVos. And even before that I was a pretty good camera club "pictorial" amateur photographer. But I knew very little about magazine photography and almost nothing about marketing pictures. Had I worked with a good free-lance photographer for maybe a year, I would have learned what it took me many, many years to learn as a do-it-yourself free-lancer. And, while learning, I would have been free from financial worry and I could have been building up a circle of customers in my spare time.

Therefore, if you decide to free-lance, go slow. Hold onto your job, whatever it is. The financial security will be more conducive to creativity. The idea

that a starving artist in his garret is more creative than his affluent peers is a lot of hogwash. You'll be far more creative if you don't have to worry about a pile of unpaid bills. Keep your job and free-lance when time permits. If you can get a job with a photographer, so much the better—there is still no substitute for the apprentice system of education.

Whether you free-lance full-time or just part-time, evenings or weekends, the next question is: Where do you start? Ask yourself: Who uses animal photography? Well, how about animal owners, for openers? Animal portrait photography has been so neglected by professional photographers that the field is wide open in all sections of the country. Did you know that the pet food industry is the fastest-growing segment of the grocery industry? Our affluent society is pet oriented, yet the market for pet portraiture photography is untapped. It's a gold mine waiting for you to work it. Why you, and not established "people portrait" photographers? Because they *are* established, and most of them are successful in what they're now doing. And the great majority of them have neither the patience nor the knowledge of pets to make good animal photographers.

I do not make portraits of pets for individuals—my illustrating work does not leave me the time. Hardly a week goes by, however, that I don't get a call from someone asking me to make photographs of his cat or dog or horse. I refer these calls to very good portrait photographers whose work I know, who are capable of producing good-quality pet portraits. But none of these photographers makes an effort to specialize in pet portraiture—and they should; they are good.

Remember back when you were starting, when you asked people if you could use their dog or cat to model for you? These very same people can now be your starting point in animal portrait photography, and you are a better animal photographer than you were then. So get in touch with these people again, and arrange for another *free* sitting. Make an 11 × 14 or 14 × 17 print of the best picture in each instance, frame it, and present it to the pet owner with your compliments. Candidly tell him that you're about to embark on a career in animal portraiture and you'd appreciate being recommended when anyone asks who did the beautiful portrait of the animal. Word of mouth advertising, you will find, will be your best salesman.

Next, get together a collection of your best pet pictures, show them to the management of your local bank, restaurant, library, art store, or department store, and ask if you can exhibit the pictures on their premises. Have a sign made to hang with the exhibit stating that the photographs were made by Joe Doak, the specialist in pet photography, and that you take pictures either in your studio or in pet owners' homes. Indicate no prices. If the people viewing the exhibit are interested, they'll call you (your name, address, and phone number should be prominently shown on your sign). Indicate also the names and owners of the animals pictured in the exhibit. People seeing the show will comment to the owners that they saw Trixie or Fido's picture on exhibit down at the bank or library. Again, word of mouth advertising. You want people talking about your work.

Go to your local SPCA or animal shelter and ask if you can photograph their strays. Then take these pictures to your local newspaper and talk them into

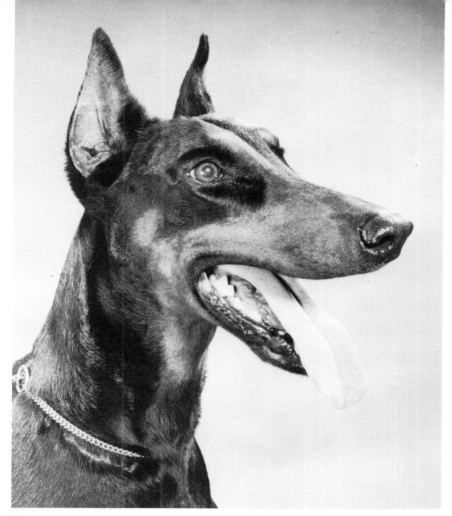

Where can you start as a part-time free-lance photographer working nights and weekends? Animal portrait photography is wide open. Most "people" photographers won't do it, and top free-lancers don't have the time for it. If you start with animal portraits, you'll be on your way to a career.

running the pictures as a weekly feature under the heading of "Adopt-a-Pet." Make a credit line a mandatory part of the deal. If you can make pictures with lots of appeal, you might even talk the editor into paying a fee for them.

Your local newspaper, in fact, is the next rung in your climb up the professional photography ladder. Whether you're in a big city or a small town, each has either a weekly or a daily newspaper that is oriented to the local scene—the neighborhood. Big city dailies like *The New York Times, Chicago Tribune, Washington Post,* and *Los Angeles Times* are too big and bustling for a beginner to tackle. Leave these for later in your climb.

Your chances of selling your first efforts will be far greater with a small neighborhood newspaper than one of the big dailies. When you start, there is nothing more discouraging than a "no," so you'd best go where your chances for a "yes" are greater. At a small paper ask for the editor or the managing editor.

Show him your work, tell him you are starting to free-lance, and you're hoping he'll *buy* some of your pictures from time to time. Let him suggest a price—and whatever it is, don't fight price initially. After you establish yourself and the editor begins to depend on you, then you can fight for a higher price. And believe me you'll have to fight. Small-town newspapers are notorious for their picayune payments. Their editors will offer a beginning photographer $3 for a great feature picture—and they will make the offer seriously and earnestly. No wonder their papers are so profitable!

Where to next? Back to your local library for research. Remember all the research you did when you were looking at pictures for quality, content, and composition? Now you're looking to find out which magazines use—or might be potential users of—animal photography. Study the magazines to see what the editors are buying. This is important. You'd be wasting your time trying to sell animal photographs to a magazine that never uses them. You're not going to sell beautiful cat and dog pictures to a magazine that deals with engineering exclusively. Nor will you sell horse pictures to a magazine dealing with office equipment. But there are many, many publications that will run stories illustrated with animal photographs. Every few months, it seems, the women's service magazines run articles on such topics as how to select a pet, what kind of dog to get

Nationally syndicated Sunday supplements have been big users of animal photographs. They like good vivid colors and sharp, tight close-ups, with a minimum of superfluous props. *Used by special permission of* Family Weekly *and* Parade *magazine.*

for your child, how tropical fish help to reduce one's nervous tension, or the problems involved in raising hamsters, rabbits, or some other kind of pet.

Another very obvious market is pet and breeder magazines—cats, dogs, horses, poultry. Each type prints numerous photos of the animals it deals with. Then there are the sporting magazines that are purchased by outdoorsmen and hunters. All these are excellent markets for pictures of hunting dogs, game birds, and animals. Farm magazines are an obvious market. Pictures of animals with children find a ready market in the women's magazines and magazines edited just for children. Really sensational shots of animals and children together will even find a market in the big general circulation magazines or the wire services. These, then, are the publications to which you are going to present, and hopefully sell, your photographs. This is getting into the semi-big time of free-lance photography.

In order to compete in a very competitive field, you must compete like a professional. Contact the editors or the art directors by mail, or personally (after first making an appointment by phone). If you make a personal visit to the office of the publication, keep in mind that you're dealing with a businessman. Although he may be "way out" in his appearance, your manners and garb should be restrained somewhat to conform to the square society that will be paying you

CATS I HAVE KNOWN

"Cats are tough to catalog," says this famous animal photographer.

"But let me tell you about some of the best to ever cross my path."

Text and Photos by WALTER CHANDOHA

LIKE PEOPLE—cats are all different. Not only do they differ in appearance, but they also differ in personality. Luckily, it's these differences in personality that make cats—and people—interesting to know.

Name any trait inherent in human beings and you'll find that same trait in a cat. Cats are graceful and cats are clumsy; they're aloof and gregarious; cunning and stupid; mysterious and obvious. They are clean and they are dirty. They are noisy and they are quiet. They are diffident and they are confident.

There was a time in history when they were worshipped as gods—by the ancient Egyptians.

There are many magazines directed to a special audience that are users of animal pictures. This story appeared in *Boys' Life* magazine. Other magazines aimed at doctors, photographers, teen-agers, boaters, farmers, and various special groups are a big, wide-open market. *Used by special permission of* Boys' Life.

DOMESTIC SHORTHAIR

Later, in the Middle Ages, they were tortured and killed because they were suspected of being witches in disguise.

They are lucky and they are unlucky—depending on the part of the world you happen to be in and the color of the cat you're looking at. In China, a multi-colored cat—the black, orange and white Calico—is called the money cat and is said to bring wealth and good fortune to its owners. Here in our country, some superstitious people believe that a black cat crossing their path is an omen of evil. Yet in England, to own a black cat means good luck. The day before he was arrested, the black cat owned by Charles I, died. The king remarked, "My luck is gone." It was. The king was later beheaded.

Whatever trait you can think of, some cat will have it. Naturally, not any one cat will possess all the traits, but all cats will have some dominant quality making them likeable—or in some cases, downright dislikeable.

Take Loco, a Russian Blue, the cat that started me on my career as a photographer of animals. From his Spanish name for crazy you can rightfully conclude that he's some kind of a nut. We've never owned a nuttier cat—but this is what makes him likeable.

He got his name early in life. After we had him for a few weeks we noticed that every night exactly at eleven o'clock he'd race around the apartment like a demon for about a minute. Then he'd stop just as suddenly as he had started and resume whatever he was doing. We could never figure out why he acted in this crazy way. My wife concluded that he must have heard a sound that was inaudible to our ears and the sound in turn triggered something in his brain which prompted his actions.

Then another trick of Loco's was to stalk me whenever I stretched out on the couch to read. No sooner would I get comfortably settled with a book but Loco would begin his game. Slowly, cautiously he'd creep toward me. Belly close to the floor, slinking forward inch by inch he'd come at me like a jungle cat. Then as he got within striking distance he'd make a flying leap onto my chest—then he'd just sit there and purr as though nothing had happened. It was a startling experience when it first happened. Later I realized it was just another of his nutty games.

Minguina, a domestic shorthair, another of our

DOMESTIC SHORTHAIR

MANX

BURMESE

138

AMERICAN GIRL

January 1961
25 cents

What you want
to know
about college

For every large, big-time maga-
zine, there are hundreds of small
magazines begging for good pho-
tography. True, their rates are
lower; but there isn't as much
competition. *Used by special per-
mission of* American Girl.

New Betty Cavanna serial

EX

PERSIAN

SIAMESE SEAL POINT

RUSSIAN BLUE

te and graceful, she is a lady in every sense of
e word. Her every motion is studied and de-
iberate. And she is the cleanest cat I've ever seen.
ormally a cat will wash after it finishes eating—
ot Ming. She feels compelled to wash after
ery second or third mouthful. Her white and
ange fur is always spotless.

It is either her good looks or her aristocratic
anner that makes her irresistible to the cats who
me to our farm to court. She has more suitors
an any of our other cats. Of all of her boy friends,
e one seems to prefer is Tiger, domestic
orthair. This big, brown striped tomcat is unique
 that he takes fatherhood seriously.

A male cat is, as a rule, completely unfamiliar
ith new-born kittens. Should he chance upon a
ter of squirming, squeaking creatures it is hard
r him to distinguish between kittens or mice or
bbits. He has no way of knowing that kittens
e his own kind. So, being a hunter by instinct,
 kills them. We have had it happen to two of
ur litters; each time a stray tom got into the barn
hile the mother cat was away from her nest.

But Tiger, a domestic shorthair, is the exception
 this case. From the time he was a half grown
at he showed much attention to kittens. His inter-
st in them persisted through maturity. No sooner
id Minguina "born" her kittens but he'd be in the
ox with her washing and fussing over them. just
 though he were the mother. And on many oc-
asions I'd have to remove a field mouse or a bird
om the kittens box. He brought these in to sup-
lement their diet.

Tiger hunted when he thought his kittens
eeded food. But this was the only time he would
unt. Spook, domestic, our big black male, always
unted. And he always brought home his trophies
f the hunt as a gift to us. Whenever he had one
f his presents, usually a mouse, he would lay it
n the doormat outside the kitchen door and
eow until someone in the house acknowledged
is presence.

One morning, as we were having breakfast, we
eard Spook calling more vociferously than usual.
s was her habit, my wife opened the door to let
e cat in—but when she saw him she slammed
e door and screamed, "He has a gigantic snake
 his mouth, and it's ALIVE!" Knowing of her
rong dislike for snakes I did my best to calm
er. That accomplished, I went outside to see

It was a tiny garter snake no fatter than a pencil
and not much longer!

The hunting prowess of the cat is a trait that
man can be thankful for. A more efficient or eco-
nomical rodent exterminator has never been in-
vented. In mills and granaries, in warehouses and
on piers, on ships and on farms, you will always
find a well-fed and much appreciated cat.

For many years the Standard Oil Company re-
finery in Bayonne, N.J., had a cat on its payroll.
So did the British Government. In both instances
the cats performed an exterminating service that
was recognized as essential and, therefore, worthy
of compensation.

Cats catch rodents but they catch birds too.
And because they do, they have made enemies of
some bird lovers.

Sometimes, when a cat goes hunting for blue
jays, he learns a lesson he never forgets. One
afternoon I noticed Grigio, a Russian Blue, climb-
ing a pear tree in pursuit of a blue jay. The sound
that that bird made as he eluded the cat must have
been a call to arms for every blue jay in the neigh-
borhood. They responded in force and in good
voice.

They attacked Grigio with more fury than a
squadron of fighter planes clearing a beach head.
They dived and they zoomed. They came at him
singly and they came at him in formation. The
poor cat was rendered immobile by the sudden
turn of events. For five minutes the attack con-
tinued. Then evidently satisfied that they had
taught the cat a lesson, the blue jays departed.

Grigio backed off the tree and, with tail drag-
ging, retreated to the safety of the porch to wash
away his shame and loss of face. From that day on
I never saw him pursuing *any* bird. As Mark Twain
said about the cat that sat for some reason on a hot
stove lid, "She will never sit down on a hot stove
lid again; but, also, she will never sit down on a
cold one anymore."

So you see, each cat has something dominant in
his personality that sets him apart from the others.
Yet, different as all cats are, they all have one
quality in common—it's moderation.

Whatever a cat is, he is only moderately so.
Whatever a cat does, he does it in moderation. A
cat is not guilty of excesses—as is man. So, if there
is one trait that man could profitably borrow from
the cat, wouldn't moderation be a start?

THE END

139

When making personal calls on prospective clients, make sure your portfolio contains a representative selection of the pictures you shoot. Include only your best picture of each type. If in doubt about any shot, leave it out.

140

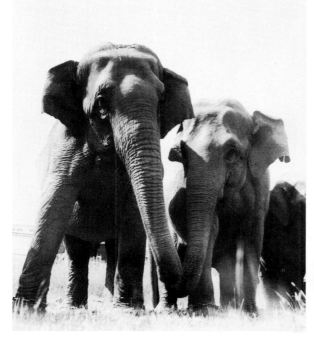

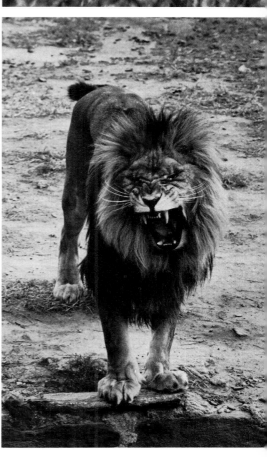

for your work. In other words, don't be a way-out, wild-eyed photographer when you go to sell your work. Wear a jacket—maybe even a tie—and if you must wear jeans, make sure they are clean. This advice may not appeal to some of our younger talents who want to do their own thing, but a tie-dyed T-shirt, dirty jeans, and sneakers are not the best outfit for making a personal contact in a big city office building. There are still too many squares around who will not realize that, beneath it all, you're the same creative genius whatever you're wearing. You might keep this in mind.

Notice that I made no mention of hair length or style. By now hair is no longer an issue with creative people in *big cities;* longer hair has become accepted. In fact the norm of many years ago—the crew cut—is much more out of place in creative offices. In small towns, however, long hair is still looked upon with suspicion, so you'll have to practice some restraint out in the hinterland.

If you make a personal contact, look personable, look presentable. But before making the personal contact you have to make the telephone contact. When you reach an editor or art director—or his secretary—be polite. Say what you have to say: You're an animal photographer. You have photographs that may be useful to the magazine. Then ask for an appointment, verify the time and date, spell your name, thank the person you've spoken to, and hang up. Keep it short and businesslike. Don't go into detail about how great your pictures are; he'll find that out when he sees them.

If you're going to sell by mail, you're up against the pros who have been doing it for years. They have printed labels, printed letterheads and envelopes. Their letters are typewritten, their pictures are fresh and clean. You'll need printed stationery too, plus cardboard stiffeners so that the pictures you send out—and get back—won't get crumpled in the mail.

When mailing out pictures, don't seal them as though the package might be going into outer space. The recipient of your goodies hasn't the time to cut open a hermetically sealed envelope and then cut apart Scotch-taped cardboard stiffeners before he can extract your beautiful pictures from a sealed plastic envelope. There is a simpler way.

Place your prints between two pieces of stiff cardboard, hold them all together with two rubber bands going diagonally from corner to corner, and insert the unit in a manila clasp envelope. The gummed flap and the clasp of the manila envelope are sufficient protection for your pictures. Your typewritten letter on your printed letterhead should be enclosed with the pictures.

Your printed address label should be typewritten and directed to the specific individual at the publication to whom you want your package to go. When it arrives there, it looks professional—much more so than one addressed on 5 & 10 cent store stock labels. Since you're competing with professionals, I can't stress too strongly that you should make a presentation like a professional.

In your covering letter to the editor or art director, state the idea you have in mind for the potential use of the pictures, and mention that they are submitted at his current rates. If the publication can use them, you'll probably get a call from the editor giving you the good news, and he'll ask how much you want. Tell him quite frankly that you're new in the free-lance business and you

The Montreal Star **Weekend** MAGAZINE

Vol. 10, No. 35 · Aug. 27, 1960

No matter where you live, you can use the mail to deliver your photographs. Publications in distant cities are as near as your mailbox. Combined with the telephone, the mail can be an effective salesman. *Used by special permission of* Weekend Magazine.

have no idea how much to charge. Suggest that he name a price. More times than not, any price you might quote would be far lower than the one he'll offer.

After you have sold a given market several times, you'll get to a point where they will call you instead of your having to call them. You may have the picture they want in your stock file, or you may be asked to shoot to a layout of a general description. When you begin to receive calls for animal pictures, you'll know there is somebody out there with enough confidence in your ability to single you out from the many thousands of photographers and ask *you* for pictures. At last you're on your way to being a real pro. If you get calls for pictures frequently enough, you might think of jumping into the field full time. But hold off a bit—there are even bigger conquests ahead.

After you've been selling pet portraits to individuals and making sales to newspapers and magazines, you'll find there are still other markets for your photographs. Some of the biggest users of animal photographs are the greeting card and calendar companies. Your next step in your marketing research program, therefore, is to go to the largest greeting card shop in a large city and carefully study the cards with animals. Why was a certain picture used on a card? Could

you do something similar? Could you do something *better*? You'll find that some of the pictures are gimmicky—the animals are dressed up, or a few of the cards have animals with most unusual expressions. Many, however, are just appealing pictures accompanied by a written sentiment appropriate to the season. The majority of the cards are in color, although in recent years a number of greeting card companies have been putting out cards using black-and-white photographs.

Look on the reverse side of the greeting card for the name of the company. All such companies are constantly looking for new material for their cards. If you feel you have something that would be good greeting card material, you can make either a personal visit or a mail presentation; but always telephone first to find out the name of the individual who looks at photography. The same advice applies here as when sending pictures to magazines and newspapers: Be a professional, and send out a professional-looking package. And until you get a feel for pricing, offer the pictures at their usual rates.

Calendar and greeting card companies are good markets for animal photographs. Study the samples you find in big-city card stores. If your pictures are as good or better, send some out to the art director of the appropriate company.

The big time of free-lancing is in the field of advertising. The rates are highest for pictures used there, but the competition is rough. This is where the pros compete against the pros. *Used by special permission of General Foods.*

There is hardly a home that does not get at least a half-dozen calendars toward the end of the year from various merchants, banks, realtors, and the like. It has become the custom for businesses to give calendars to their customers —free, as a token of good will and to serve as a reminder of the donor throughout the year. In addition to these free calendars, others are sold in the stores that sell greeting cards. These are manufactured by the greeting card companies, and are mostly 12 sheet—i.e., a page for each month. They carry no advertising message but are illustrated with attractive photographs of many subjects, including animals.

If you've been selling photographs to magazines, newspapers, and calendar and greeting card companies, you're now ready for the real big time—where the pros are separated from the amateurs: the field of advertising photography. This is the highest paying area of still photography, and because the fees in advertising are tops, this field also attracts the top professional photographers. For example, a photograph of a dog with a marvelous expression might sell to a greeting card company for $200. But if a dog food manufacturer saw the picture and decided it was just the shot he needed for an ad in national magazines, he might pay $2,000 for the same picture.

Because the fees are so attractive, the competition is fierce. There are actually hundreds of photographers competing for a single job. Who gets the job?

The photographer with the most talent? Sometimes. The photographer with the most contacts? Sometimes. But most of the time the job will go to the specialist—the guy who has made a reputation for himself as the most capable, competent, and creative photographer in that given field.

Very few photographs used in national advertising in mass circulation magazines come from stock sources. The majority of advertising illustrations are custom-made to a layout. This layout is a creative team's concept of what the

Another big-time area at the pinnacle of free-lancing is photography for packaging. As in all areas of advertising photography, the competition is keen. *Used by special permission of Ralston Purina Company.*

Sometimes the requirements for packaging photography are very exacting. The photograph must fit into a certain area, leaving room for copy, logo, and product name. *Used by special permission of Ralston Purina Company.*

finished ad might look like when it appears in a magazine or newspaper. The art director has made a rough sketch of the illustration, and the headline supplied by the copywriter has been lettered in the appropriate place. The layout is then given to the photographer, who is commissioned to produce a photograph as close as possible to the art director's sketch.

When an advertising agency calls me, I like to think they chose me not only because they have faith in my ability to deliver the photograph they want, but also because they hope I will provide them with something more than what their creative team has come up with. So when I get such an assignment I will shoot a photograph as close as I can to the concept of the layout. But, in addition, if the assignment is such that there is a little flexibility in the concept, I will also make a photograph of what I think the client should have. I do this because creative people are not always aware of what an animal will or won't do in a given situation. And, in many cases, the people in agencies are given assignments without any regard for their knowledge of or rapport with animals. More than once I've had art directors in my studio who confessed they hated cats, didn't understand them, and would be glad when "this stupid job is over with." Can't get much creativity out of an individual like that!

When I deliver an assignment—one group of pictures as close to the layout as possible and one group the way I think the pictures *should* be—sometimes my concept is accepted and sometimes the agency's concept is accepted.

Both stock photographs and custom photography are used for packaging illustrations. Because of the design factor, more and more clients are turning to stock photographs in recent years. *Used by special permission.*

An advertising "campaign" consists of a series of ads using the same copy theme and running for a given period of time. All the ads follow this theme but the illustrations, though similar, are varied. *Used by special permission of General Foods.*

by Walter Chandoha, World Famous Cat Photographer

KITTEN-SOFT MARY KING

Pink Silk Lotion

Smooth, Kitten Soft skin . . . yours when you use Mary King Pink Silk Lotion regularly. Extra kind to legs, elbows, or wherever your skin chaps easily. Pink Silk dries quickly, leaves no filmy after-feel . . . has such a delightful fragrance. Try Pink Silk before you buy it. Your Watkins Dealer will be more than glad to demonstrate its quality. *If he has been missing you at home lately, look in your phone book for* **WATKINS QUALITY PRODUCTS.**

Watkins

THE SHOPPING SERVICE THAT COMES TO YOUR HOME · **90th** · *Diamond Jubilee* **1868-1958**

MONEY SAVING OFFER! In celebration of Watkins 90th year in business, your Watkins Dealer has, this month only, a special offer on Mary King Hand Cream . . . formulated with lanolin.

THE J. R. WATKINS COMPANY . . . WINONA MINNESOTA · NEWARK · MEMPHIS · OAKLAND · MONTREAL · WINNIPEG · AUSTRALIA · NEW ZEALAND · SOUTH AFRICA

THIS AD APPEARS IN FEBRUARY ISSUE OF GOOD HOUSEKEEPING

PRINTED IN U. S. A.

As a free-lance photographer, you'll have many up and down periods—not only financially but also creatively. But, with determination and imagination, if you persist you can make it to the big time—illustrating advertisements, such as this one, which appeared in *Good Housekeeping* magazine. *Used by special permission of the J. R. Watkins Company.*

You must be diplomatic when you present your idea as being a better way to solve the problem than the one envisioned by the art director. Some art directors are prima donnas, reluctant to admit that any idea or way to illustrate an ad is superior to theirs. Other art directors, however, are delighted that you could come up with a variation and will fight to get your concept accepted.

As a specialist in animal photography, you're going to get assignments to do custom photography to layouts. You can hack it and do only what you're told to do, or you can put a little of yourself into the assignment—your lighting, your printing, your ideas. In some way, your expertise should make your picture more outstanding than your competitors' pictures. You'll have to do this or you won't stay on top for long.

Other potential markets for animal photographs are book publishers, encyclopedias, annual reports, candy box manufacturers (mostly abroad), playing card companies, and jigsaw puzzle makers. And don't forget record covers. You'll find plenty of places to sell your pictures if you're alert and aware of the world around you.

Once while waiting in a doctor's office for a travel shot, I found a magazine I'd never heard of. I wrote down the name of the editor and the magazine address, and sent some pictures to him the next day. They sold at once. And within six months, I sold over $1,200 worth of stock pictures to that magazine. A good exchange for a $10 office visit to my doctor.

Now that you're selling your pictures regularly, you may be ready to cut the umbilical cord—that is, give up the security of a regular weekly paycheck and take the plunge into the uncertain but exciting world of free-lancing. If you've been so busy as a part-time free-lance that you have occasionally had to take a day off from your "security" job to catch up on your animal photography assignments, then you have certainly reached that point.

But make no mistake about it—when you free-lance full-time, that backlog of work will disappear pretty fast. You'll have to beat the bushes for more business. There will be times when "nothing will be coming in." These times hopefully will be balanced by an inundation of checks that will be greater than you ever dreamed. However, because you cannot escape having lean as well as fat periods, you'll have to plan your finances. When you get some of those big fees, beat down the temptation to get a brand-new car or that new telephoto lens you've been doing without all these years. Bank most of the windfall for a rainy day. No matter how sunny the outlook is and no matter how good a photographer you may be, when you free-lance you have many rainy days.

But the sun will shine—far brighter than you've ever imagined—and eventually the uncertainty will pass. You'll gain more confidence with each new assignment. You'll soon wonder why you didn't turn to free-lancing years and years ago.

As a professional free-lance photographer, you have the ideal job—a job many would like but few can attain. Let's face it: in what other job do you have no boss, no time clocks, unlimited time off, excellent pay—and no sweat?

INDEX

Italic numbers refer to pages with illustrations